Sea of Ghosts

wnstar Winterhold

im Windhelm Blacklight

Gnisis

Vvardenfell Dagon Fel

Firewatch

Threat of the world Red mountain

Riften Ald'ruhn Sadrith Mora

Bruma Balmora

Seyda Neen Vivec Necrom

Cheydinhal

Morrowind

Imperial City Mournhold

Narsis

Tear

Niben bay Stormhold Thorn

iverhold Bravil

Orcrest Rimmen Black M

sweyr Helstrom

Corinthe Leyawiin Gideon

Tenmar forest Topal bay

rval Archon

Senchal Soulrest Blackrose

Lilmoth

The Padomaic Ocean

T0418280

The Elder Scrolls®

TASTES AND TALES
FROM TAMRIEL

The Elder Scrolls®

TASTES AND TALES
FROM TAMRIEL

By Urzhag gro-Larak

As translated by Victoria Rosenthal and Erin Kwong

INSIGHT
EDITIONS

SAN RAFAEL · LOS ANGELES · LONDON

CONTENTS

INTRODUCTION

It's strange writing an introduction after years of work, when the book is finally close to finished. It feels like an opening where there should be a close, if that makes sense. But, if my journey to write this collection has taught me anything, it's that beginnings are often disguised as ends. So I'll do my best to write an introduction, starting at the beginning.

I grew up at Mor Khazgur, a proud stronghold of miners. My father led our fortress on the values of hardiness and battle fortitude. Which made my life slightly miserable, as I proved incapable of either! I was scrawny for an Orc and had embarrassingly cerebral interests. While others my age trained with swords and crossbows, I hid in a nook of the longhouse and read anything I could get my hands on.

Historical accounts were my favorite, even the many bloody war tales. I shook at the sight of a weapon, but learning about who clashed with whom, and when, and why—that was different. From Tiber Septim's conquest to the formation of the Knights of the Nine, and how the falling of Baar Dau eventually led Vivec City to become the Scathing Bay, I began to piece together the story of Tamriel. When others made harsh remarks about my lack of strength or my weak aim, I'd pretend to be someone else—an Aldmeri scholar studying at the college of Sapiarchs or a Breton mage conjuring up wondrous spells. Anything to take me away from my own failures.

Until I came across *Uncommon Taste*.

It was the first cookbook I'd read. One day, I snuck away from the mines to experiment. I diced carrots, combined broths, and stirred vigorously. The result was delectable: a heavenly savor that sparkled on my tongue. The scent was at once soothing and potent and wafted all the way up to the mines. To my chagrin, the miners stormed into the kitchen and discovered me. They wrenched the pot from my hands, wolfed the whole thing down . . . *and asked me for more.*

For the first time in my life, something I'd done had drawn respect! I found my calling in that Potage le Magnifique.

With newfound support, I continued to perfect every dish in *Uncommon Taste* until I could whip up a Kwama Egg Quiche by memory. I'd been starting to experiment with some creations of my own, when serendipitously, word came to Mor Khazgur that the Gourmet, author of my beloved recipes, was visiting Solitude. The Gourmet was famously a secretive person—no one knew who he was. He'd be nearly impossible to locate. But still, the chance to meet the chef who had changed my life! I set out on the next Morndas morning with a pack of provisions and a new frying pan my brother forged me.

When I entered the Winking Skeever inn, the only other person there was another Orc dressed in more refined garb than I'd ever seen our kind wear. I sat down at the other end of the bar—I'd never been good at talking to strangers—but he introduced himself as Balagog gro-Nolob, and we were soon discussing cuisine. I made a fool of myself, babbling on and on about *Uncommon Taste*. It was after midnight when Balagog leaned across the bar and whispered with a conspiratorial wink, "You must keep this a secret, but the Gourmet isn't actually all he's cracked up to be. He's only an old Orc with a penchant for nice clothes."

Imagine my shock! For the next few days, I oscillated between apologizing profusely and begging him to mentor me. He repeatedly refused, but he did allow me to taste his dishes. By Fredas, I'd worked up the courage to cook for him.

For hours, I waffled between which recipe to choose: Something extravagant, to prove my good taste? Something from *Uncommon Taste*, to demonstrate my admiration? None of these felt right, none of them could correctly package a gift equal to that he had unknowingly given me. At the time, I was rather awful in high-stress situations. But that pressure reminded me of a little jewel I often made to comfort myself: a simple bratwurst on a bun, topped with cabbage and mustard. I worried that it was too crude, but as I simmered the cabbage and sautéed the onions and saw the brats take on their gorgeous shine,

my fears fell away. Until, of course, I presented the finished dish.

I will never forget Balagog's face as he ate. He didn't say a word from the first bite until his bowl was clean. He wore an uncharacteristic frown that slowly turned contemplative with each spoonful. I nearly soiled my trousers waiting for him to speak, but when he finally did, it was only:

"Three months. I'll teach you for three months."

Balagog taught me to see food in ways I'd never thought of before, giving me context to the rise and fall of certain recipes throughout history, how they were influenced by magic, by politics, by music. He told me stories of how he'd come to learn searing methods and spicing techniques. And there was one thing he said again and again: "I can teach you this, but you won't know it until you've cooked for Tamriel yourself." At the end of three months, he left me with a desire to travel the world and a promise to meet back up again when I'd finished.

So I did. I traveled to different lands and had experiences new and sometimes harrowing! From Northpoint to Sunhold, from Senchal to Vvardenfell, to the Imperial City and back around again. As I traveled, I found a particular love in researching and re-creating historic dishes. I never could have guessed the unexpected origin of Gold Coast Mudcrab Fries! And who would have known that there was so much Imperial war history packed into a Colovian War Torte? It was dishes like these that inspired me to write a book. Over the years, I imagined Balagog's excitement when I presented him with a copy—his pride, perhaps. After four years, I finalized my collection and wrote to Balagog to arrange to meet up in the Pale. I was three miles away when I heard he was dead.

What had I done this all for? All my careful study, the leagues I had walked, the burns on my hands. My mentor, my inspiration, was gone. He'd never see how far I'd come. I crawled home. For days, the only thing I'd eat was tasteless gruel placed by my bedside. The end had come before anything had even begun.

I don't remember how many moons went by before I began to notice, in spite of myself, that the gruel I was eating was starting to actually taste . . . good? I realized the hands that were bringing me meals were those of my sister, the most hardened warrior of Mor Khazgur, who had never cooked anything except explosions. When I asked, she admitted to me that she'd started to use ginger and allspice, according to one of my recipes—and that she was *enjoying* it. Like an Orc coming out of a mine and into the sunlight, I bashfully showed her the collection I'd been working on for so long. Night after night, we worked together in the kitchen, me the teacher, her the student, and my passion began to return.

What had I journeyed for? Wasn't it to spread the tales that I'd loved to read, and learn new tales from others? Wasn't it to share the passion that I'd found in that Potage le Magnifique? Yes—Balagog had ignited a spark in me, and if I could ignite that same spark in my steel-hearted sister, I could share it with anyone.

Which brings us here, to the end of my introduction. The end of my current adventure, and I hope, the beginning of yours. In reading these recipes, you will absorb the heart and history of Tamriel. In replicating the meals and adjusting them to your own taste, you continue to add to the story of our wild and wonderful lands! There is nothing more that I wish than this, for endings such as Balagog's and my own to ignite the spark, to keep the flame on the stovetop going. Thank you for being a part of that fire.

And one last thing I must say, since I was once a nervous young Orc with little confidence: You don't need fancy equipment or years of practice to become a gourmet chef! For as Balagog would say, the secret ingredient is you.

BREAKFAST

BREAKFAST

◆

"Breakfast is the most important meal of the day." If you live in Tamriel, you've likely heard this old adage. I was curious to find out where and when the saying had originated, so I took particular note to look out for it as I visited libraries and restaurants. I wasn't able to discover its genesis, but I did discover that by the Second Era the saying had proliferated enough that Queen Ayrenn Arana Aldmeri was rumored to believe it the absolute truth. She was said to ensure a large morning meal for every single Aldmeri soldier. (Though, as with all historic records, there are just as many accounts that refute this notion and claim Queen Ayrenn starved her troops.) Still, the key to a successful Dominion might have been as simple as tomatoes every morning instead of solely sausage!

Unlike Queen Ayrenn, I had never subscribed to the idea of using breakfast to set yourself up for a successful day. I didn't have a favorable opinion of breakfast growing up: Every morning, I'd wake up to a plate laden with unseasoned deer intestine and tasteless gruel. The elders thought me weak and constantly tried to energize me in preparation for full days in the mines. In hindsight, this may have been meant to help, but at the time it just made me feel groggy, sluggish, and slow. I always felt that if I had the choice to skip breakfast, I would.

So of course, on the morning of my journey out into the world, I didn't eat breakfast.

After finishing my training with Balagog, I'd made my way to Riften. There I had planned to cross the border into Cyrodiil. This would be the official beginning of my travels and my first steps outside Skyrim, for I had never left the northern lands before. That morning was oddly emotional: Up to this point, I had been excited to see the world, to travel as my mentor had. But now I was faced with the magnitude of my journey, and all I could feel were nerves and anxiety. I hadn't had a wink of sleep and felt queasy already. The inn had prepared porridge for their guests, but I walked straight outside to get some air.

I spent the morning pacing around the city, contemplating my options and muttering to myself. Was I mad to take on the world, when I barely knew how to wield a sword? Was I full of myself, comparing myself to Balagog? Would it be wiser if I just turned around and went home? As the sun rose overhead, I realized I didn't recognize my surroundings. Just as I turned around to try to get my bearings, I felt rough hands grab my shoulders. My sight went dark as a bag was forced over my head. I started to protest—then felt a sharp pain on the back of my head.

The next thing I remember was waking up in a cold

place. All I could feel were a few thin strands of straw between me and the stone floor. My only companion was the sound of dripping water. I thought about calling for help, but my mouth was so dry—and what if they retaliated? Instead, I sat there silently in the dark, feeling my empty stomach twist, lamenting my fate. This is how it would end, before it even began!

Hours passed. I felt myself weaken to hunger with every second that slipped by. It felt like days before I heard voices. My captors! They spoke in the next room.

"You've got him?"

"Aye, Gregof, we do."

"And you're sure it's him?"

"Well, we heard him muttering before we bagged him saying 'the Gourmet, the Gourmet' and his stuff's a bunch of cookbooks and a frying pan . . ."

"Well, that's the Gourmet then, is it not? Fetch a high ransom. What's the problem?"

"Right. Well, only thing is . . ."

A door—the door to my cell—opened and the bag was unceremoniously ripped off my head.

"He's an Orc."

I blinked in the dim light. Three burly Nords stared down at me.

"Hallmar, you fool! How could the Gourmet be an Orc?" My captors argued as I tried to comprehend

my situation. Could it be that they had taken *me* for Balagog? That they believed me the Gourmet? Perhaps my starved delusion made me foolish, but a sliver of pride shot through my fear and I worked up the courage to speak.

"Please, sirs," I croaked. "With all due respect, this gentleman—Gregof?—is right. I'm no Gourmet. I'm simply a crude beginner chef."

My stomach burbled piteously, as if to back my claim—I hadn't eaten breakfast. The rogues looked at me with uncertainty, and I pressed on.

"And I hate to disparage—er, bring down my own kind, but surely there's no way the Gourmet could be Orsimer! After all, how could a mere Orc ever master even the basic Nordic recipes? Solitude Salmon-Millet Soup? Solitude Bread? Apple Mashed Potatoes? *Solitude Full Breakfast*?!"

Apparently, the idea of an Orc cooking Nordic meals was too much for them, because they dropped me back in the streets. After a shaky walk back to my inn, a hearty bowl of porridge, and two cups of tea, I felt my convictions solidify. After this, I could make it through anything—though I never wanted to go through a misadventure on an empty stomach again. The next morning, I made sure to cook up a delicious Solitude Full Breakfast and took my first steps outside Skyrim.

ARENTHIA'S EMPTY TANKARD FRITTATA

This frittata is a true fusion of Bosmer and Khajiit cuisine! I stopped by a little tavern in Arenthia on the way out of Valenwood. The Empty Tankard was run by a family of Khajiits. When the tavern first introduced their signature frittata to the locals, it was very unpopular—too sweet, and not enough meat for the Bosmer diet. Over time, the family adjusted the ingredients to be more Bosmer friendly. The version they made for me included vegetables, however, so purists of the Green Pact may need to make some substitutions.

Level:
Prep Time: 20 minutes
Cook Time: 55 minutes
Yield: 4 servings
Dietary Notes: Dairy-free, gluten-free
Cuisine: Bosmer / Khajiit
Equipment: 10-inch cast-iron pan

ROASTED POTATOES

Nonstick cooking spray, for greasing the pan

12 ounces Yukon gold potatoes, peeled and cut into large chunks

1 tablespoon olive oil

1 teaspoon kosher salt

1 teaspoon ground black pepper

1 teaspoon sugar

2 teaspoons dried thyme

1 teaspoon dried basil

FRITTATA

6 eggs

Nonstick cooking spray, for greasing the skillet

8 ounces chorizo, cut into large chunks

5½ ounces shoulder bacon, cut into bite-size pieces

3 ounces bacon, cut into bite-size pieces

½ onion, cut into large chunks

10 cherry tomatoes, halved

3 garlic cloves, minced

To make the roasted potatoes:

1. Preheat the oven to 425°F. Grease a baking sheet with cooking spray.
2. In a medium bowl, combine the potatoes, olive oil, salt, pepper, sugar, thyme, and basil and toss until coated. Transfer to the baking sheet.
3. Bake for 20 minutes. Toss and cook for another 10 minutes. Set aside.

To make the frittata:

1. In a small bowl, whisk together the eggs.
2. Grease a cast-iron skillet with cooking spray and heat over medium-high heat. Add the chorizo and cook until lightly browned. Remove the chorizo from the pan and place on a plate. Add the bacon slices to the pan and fry until cooked through. Transfer the bacon to the same plate as the chorizo, leaving the grease from the bacon in the pan.
3. Add the onion and cook until softened, about 5 minutes. Add the tomatoes and garlic and cook for another 3 minutes. Add the roasted potatoes, chorizo, and bacon. Toss together until well mixed.
4. Pour the eggs evenly around the pan, coating everything. Reduce the heat to medium-low and cover. Cook until the eggs are just about set, 7 to 10 minutes.
5. Uncover and place the pan under a broiler. Cook until the eggs are fully set, 2 to 3 minutes. Remove and let rest for 2 minutes before cutting into wedges to serve.

BUBBLE AND SQUEAK

By the time I made it to Daggerfall, I'd learned a bit about smart travel and bought passage on a merchant ship as they made their trade along the coast of Iliac Bay. Much of that voyage was fascinating, but I was particularly struck by the marvelous Adamantine Tower. Possibly the oldest structure in the world! Made by the gods! At some point the cage to a sorceress?! The sailors aboard were perfectly willing to supply me with wild and fantastical rumors about the shining structure—in exchange for a scrumptious breakfast. I spent many mornings onboard frying up Bubble and Squeak with leftovers from the night before. This easy recipe kept us all fed: the sailors with enough stamina to do their work, and me with wondrous stories.

Level: ◁▯▮▮▮▷
Prep Time: 45 minutes
Inactive Time: 30 minutes
Cook Time: 30 minutes
Yield: 4 patties
Dietary Notes: Gluten-free
Cuisine: Breton

MASHED POTATOES

½ pound russet potatoes, peeled and chopped

½ teaspoon kosher salt, plus more as needed

2 tablespoons unsalted butter

2 ounces sour cream

Pepper

BUBBLE AND SQUEAK

4 slices duck bacon, chopped

Mashed potatoes

1 tablespoon duck fat

7 napa cabbage leaves, chopped

1 leek, white and green parts only, chopped

Nonstick cooking spray, for greasing the pan

To make the mashed potatoes:

1. Place the potatoes in a large pot with just enough water to cover them, add the salt, and bring to a boil over high heat. Reduce the heat to a simmer and cook for 15 to 20 minutes, or until the potatoes are tender. Drain and set the potatoes aside.

2. Place the pot back on the stove and add the butter and sour cream. Heat over medium heat and cook until the butter has fully melted. Add the potatoes and mash until smooth. Season with salt and pepper to taste.

To make the Bubble and Squeak:

1. Heat a medium nonstick pan over medium-high heat. Place the duck bacon and cook until crispy. Transfer the bacon to the bowl with the mashed potatoes, leaving any fat in the pan.

2. Add the extra duck fat, cabbage, and leek to the pan. Cook until softened and slightly crispy, about 10 to 12 minutes. Transfer to the bowl with everything else.

3. Mix everything until it just comes together. Split into four equal portions. Prepare a small baking sheet with parchment paper. Form each portion into a patty and place on the prepared baking sheet. Place in the refrigerator, uncovered, for 30 minutes.

4. Heat a large cast-iron pan over medium-high heat. Spray with nonstick oil and place the patties in the pan. Cook until golden brown, about 3 to 5 minutes. Flip and cook until golden brown, another 3 to 5 minutes. Serve warm.

FUNGUS OMELET

While traveling along the Bitter Coast, I met an Argonian who was kind enough to share this recipe along with some ancestral history. The chef who coined this dish was named Chow-Chow and had lived in Seyda Neen. My new friend even told me that their love for Fungus Omelets could be a sign that they received Chow-Chow's soul from the Hist! I couldn't tell if they were joking, but their mushroom recommendations were spot-on.

Level:
Prep Time: 15 minutes
Cook Time: 20 minutes
Yield: 1 serving
Dietary Notes: Dairy-free, vegetarian
Cuisine: Argonian

SAUTÉED MUSHROOMS

2 tablespoons olive oil

1 shallot, thinly sliced

5 ounces lion's mane mushroom, sliced

3 ounces oyster mushroom, sliced

2 ounces beechnut mushrooms, chopped

1 teaspoon ground black pepper

½ teaspoon kosher salt

OMELET

Nonstick cooking spray, for greasing the pan

3 eggs

To make the sautéed mushrooms:

1. In a medium pan, heat the olive oil over medium-high heat. Add the shallot and cook until softened, about 2 minutes. Add the mushrooms and cook until they have turned golden brown, 10 to 15 minutes.
2. Remove from the heat and season with black pepper and salt.

To make the omelet:

1. Begin warming a medium pan over medium heat. Spray the pan with cooking spray. Once it is warmed, add the beaten eggs and give them a few good swirls with a spatula. Spread the eggs out and let them cook for about 3 minutes or until the edges begin to solidify. Carefully flip the eggs and allow them to cook for another minute. Remove the omelet from the pan and carefully place it on a plate. Pile the sautéed mushrooms on half of the omelet and fold the other half of the omelet over to cover the mushrooms.

KWAMA HASH

Traveling through Morrowind was eye-opening in many ways. I joined a caravan for much of the journey, as I was told traveling alone would be too dangerous. The Red Mountain rumbled continually. Ash filled the sky. Days and nights blurred together, as we rarely saw the sun. I rode most often with an older Dunmer woman named Synali. She passed the hours telling me stories of her youth, and once she mentioned how kwama eggs reminded her of the home she had lost. The next morning, I spent hours piecing over the local area until I'd found a nest. Her beaming face is one of my loveliest memories from the road.

Level: ◁▮▮▯▷

Prep Time: 30 minutes

Cook Time: 25 minutes

Yield: 4 servings

Dietary Notes: Vegetarian

Cuisine: Dunmer

Equipment: 10-inch cast-iron pan

2 teaspoons chile powder

1 teaspoon ground cumin

1 teaspoon ground coriander

1 teaspoon paprika

1 teaspoon Mexican oregano

½ teaspoon garlic powder

2 tablespoons olive oil, divided

1 onion, chopped

1 red bell pepper, chopped

2 garlic cloves, minced

2 sweet potatoes, peeled and diced

2 carrots, peeled and diced

Kosher salt

Ground black pepper

4 duck eggs

TO SERVE

Feta cheese, for serving (optional)

Tonkatsu sauce, for serving (optional)

1. In a small bowl, combine the chile powder, cumin, coriander, paprika, Mexican oregano, and garlic powder. Set aside.
2. Heat a medium cast-iron pan with 1 tablespoon olive oil over medium-high heat. Add the onion and red bell pepper and cook until softened, 8 to 10 minutes.
3. Add the garlic and cook for another 2 minutes. Transfer to a plate. Add the remaining tablespoon of olive oil and heat up. Add the sweet potatoes and carrots and cook until the vegetables are softened and tender, 10 to 15 minutes.
4. Return the onion mixture to the pan. Add the spice mixture and toss until everything is coated well. Season with salt and pepper to taste.
5. Make four small wells in the mixture. Place an egg in each of the wells. Cook and cover until the eggs are set, about 3 minutes. To serve, carefully scoop a portion with the egg still intact. If using, top with feta cheese and tonkatsu sauce.

OLD ALDMERI ORPHAN GRUEL

This porridge has a truly interesting journey through the ages. Its origin is difficult to pinpoint, as the Altmer have warred often through many eras, keeping the number of orphans unfortunately high. In peacetime, this gruel has been served at Aldmeri New Life Festivals—a tasty reminder of the past sacrifices made to reach another year. With the recent tensions between the Dominion and the Empire, however, the dish has taken on a new life. All across Tamriel, I've seen both Altmer and Imperial forces relying on different iterations of Old Aldmeri Orphan Gruel to sate orphans and fuel soldiers alike. I include this recipe to memorialize the unique moment we are in, and as a prayer for times of peace to come.

Level: ◇▭▭▭◇

Prep Time: 30 minutes

Inactive Time: 2 hours

Cook Time: 1 hour

Yield: 2 servings

Dietary Notes: Dairy-free, vegan

Cuisine: Altmer

GRUEL

½ cup pearl barley

1 cup oat milk

1 cup water, plus more if needed

¼ cup pumpkin purée

2 tablespoons dark brown sugar

½ teaspoon ground cinnamon

¼ teaspoon ground ginger

¼ teaspoon allspice

Pinch ground clove

½ teaspoon vanilla paste

Pinch kosher salt

TOPPING

¼ cup roasted pumpkin seeds

2 tablespoons walnuts, crushed

2 tablespoons pecans, crushed

2 tablespoons golden raisins

2 tablespoons dried cherries

To make the gruel:

1. Place the barley in a small bowl and cover completely with water. Cover with a kitchen towel and soak for 2 hours. Drain and discard the water.
2. In a medium pot, combine the milk, water, pumpkin purée, brown sugar, cinnamon, ginger, allspice, clove, vanilla paste, and salt. Bring to a boil. Add the drained barley and reduce the heat to low. Cover and simmer until the barley is soft and tender, 45 to 60 minutes.

Note: Keep an eye on this at around 30 minutes of cook time. If the liquid has drained completely, add additional water. If the barley is still not soft, continue cooking and adding water if needed.

To assemble:

1. In a small bowl, combine the pumpkin seeds, walnuts, pecans, golden raisins, and dried cherries. Split the gruel between two bowls and divide the topping evenly between them.

PEAR SWEETCAKES

This lush delicacy is popular in Cyrodiil, but many enjoy it without knowing its historical relevance! Though pear sweetcakes had been baked before 4E 175, the Empire pushed its popularity with the signing of the White-Gold Concordat, in the hopes of bolstering perception of the treaty. Pears were ripened specifically to be white and gold, happily heightening their sweetness. The demand for this breakfast item soared—though the same cannot be said for support of the concordat.

Level: ◁▭▭▭▷

Prep Time: 15 minutes
Inactive Time: 35 minutes
Cook Time: 40 minutes
Yield: 8 scones
Dietary Notes: Vegetarian
Cuisine: Imperial

- Nonstick cooking spray, for greasing the baking sheet
- 2 tablespoons unsalted butter
- 1½ cups pears, peeled, cored, and chopped
- 2¼ cups all-purpose flour
- 2 teaspoons baking powder
- 1 teaspoon kosher salt
- ½ teaspoon ground cinnamon
- ½ teaspoon ground allspice
- ¼ teaspoon ground cloves
- ⅓ cup sugar
- ½ cup unsalted butter, cubed and frozen
- 1 cup buttermilk
- 1 teaspoon vanilla extract
- 1 tablespoon heavy cream

1. Line a baking sheet with parchment paper and grease with cooking spray. Set aside.
2. In a small nonstick pan, heat the butter over medium-high heat. Add the pears and cook until they become slightly golden brown, 8 to 10 minutes. Remove from the heat and let cool completely.
3. In a large bowl, combine the flour, baking powder, salt, cinnamon, allspice, cloves, and sugar.
4. Add the frozen butter and combine with your hands until it resembles coarse cornmeal. Add the pears and mix until combined. In a small bowl, combine the buttermilk and vanilla. Add the buttermilk mixture to the large bowl and mix until it just comes together, but do not overwork.
5. Transfer the dough onto the countertop and form into an 8-inch-wide circle. Cut into 8 equal wedges. Place the scones on the prepared baking sheet. Place in the freezer and let rest for 30 minutes.
6. Preheat the oven to 375°F. Brush the top of the scones with heavy cream. Bake for 30 to 35 minutes or until golden brown.

SOLITUDE FULL BREAKFAST

I thoroughly enjoyed the time I spent in Solitude. A metropolis like nothing else in Skyrim! In the rare moments I wasn't training with Balagog, I often strolled along the docks, marveling at all the ingredients shipped into the city by the East Empire Company. The city was packed with Imperial soldiers as well, training in the squares, patrolling the streets, and drinking into the early hours. The Winking Skeever was often their watering hole of choice—many times, I would see twenty soldiers at the bar on the way to bed, and those same twenty there again in the morning, eating this hearty meal! They claimed it was the ideal hangover cure. Although I can't speak to the veracity of that claim, I can confirm that the Nordic combination of sausage, eggs, and beans makes for a delicious breakfast.

Level: ◁▭▭▭▷
Prep Time: 1½ hours
Inactive Time: 2 hours
Cook Time: 1 hour
Yield: 4 to 6 servings
Dietary Notes: N/A
Cuisine: Nord / Breton

SALMON SPREAD

8 ounces cream cheese

3 ounces sour cream

4 ounces smoked salmon

1 teaspoon dill

½ teaspoon caraway seed

1 teaspoon lemon zest

2 teaspoons lemon juice

½ teaspoon ground black pepper

ROASTED VEGETABLES

Nonstick cooking spray, for greasing the baking sheet

2 pounds Yukon gold potatoes, peeled and cut into large chunks

2 tablespoons olive oil

1 teaspoon kosher salt

½ teaspoon ground black pepper

1 teaspoon dried thyme

20 mushrooms, quartered

20 cherry tomatoes

To make the salmon spread:

1. In a medium bowl, whisk together the cream cheese and sour cream.
2. Add the other salmon, dill, caraway seed, lemon zest and juice, and pepper and mix until just combined. Place in an airtight container and refrigerate for 2 hours before serving. Can be stored in the refrigerator for up to 1 week.

To make the roasted vegetables:

1. Preheat the oven to 425°F. Grease a baking sheet with cooking spray and set aside.
2. Place the potatoes in a medium pot and fill with just enough water to cover. Bring to a boil over medium-high heat. Once boiling, reduce the heat to medium and simmer for 10 minutes. Drain the potatoes and transfer to a medium bowl.
3. Add the olive oil, salt, pepper, and thyme to the bowl and toss until coated. Transfer to the prepared baking sheet.
4. Bake for 10 minutes. Toss, then add the mushrooms and tomatoes to the baking tray and bake for another 20 minutes. Keep warm until ready to serve.

Recipe continues on page 26.

Recipe continued from page 25.

BEANS

1 tablespoon olive oil

¼ onion, finely chopped

1 garlic clove, minced

2 tablespoons tomato paste

1 tablespoon honey

½ teaspoon Worcestershire sauce

1 teaspoon unsulphured molasses

1 tablespoon dark brown sugar

½ teaspoon kosher salt

½ teaspoon ground black pepper

½ cup chicken broth

2 tablespoons apple juice

1 teaspoon apple cider vinegar

15 ounces canned navy beans,
 drained and rinsed

½ tablespoon cornstarch

1 tablespoon water

NORD STANDARDS

6 ounces smoked salmon

8 hard-boiled eggs, shelled

Solitude Bread, sliced,
 for serving (page 73)

8 ounces brie

8 ounces Jarlsberg cheese

16 ounces skyr

6 ounces blueberries

BRETON ADDITIONALS

12 slices shoulder bacon, cooked

10 sausage links, cooked

Note: Swiss, Gruyère, or
Emmental cheese can be used in
place of Jarlsberg. Skyr is a type
of yogurt; full-fat Greek yogurt
works as a replacement in a pinch.

To make the beans:

1. While the vegetables are roasting, in a medium pot, heat the olive oil over medium-high heat. Add the onion and garlic and cook until the onion has softened, about 8 minutes. Add the tomato paste, honey, Worcestershire sauce, molasses, brown sugar, salt, and pepper. Toss until the onions are coated.

2. Add the chicken broth, apple juice, and apple cider vinegar and mix until well combined. Bring to a boil. Reduce the heat and simmer for 10 minutes.

3. Add the navy beans and cook until heated, about 5 minutes. In a small bowl, combine the cornstarch and water. Add the mixture to the pot, mix together, and heat up until it thickens, about 2 minutes. Keep warm until ready to serve.

To assemble and serve:

1. While the beans and vegetables are finishing up, take the salmon spread out and let rest at room temperature for 15 minutes before serving.

2. Place the roasted vegetables, smoked salmon, hard-boiled eggs, brie, and Jarlsberg on a large serving tray. Place the skyr in a large bowl with the blueberries, which can be served on top or on the side.

3. Transfer the beans into a bowl. Place the bacon and sausage on another plate. Cut several slices of Solitude Bread.

TOAD MUFFIN

I was fortunate one year to spend the 26th of First Seed in the city of Rihad, near the mouth of the Brena River. Though Rihad is south of the Alik'r Desert, its people celebrate the Festival of Blades as well! During the parades, I met a small boy who looked rather downtrodden—he told me he didn't have enough pocket money to go and buy scuttle fondue or goat nibbles. What he had at home was only enough to cook bland toad muffins. I'm familiar with doing a lot with a little—I took some spices I had bought that morning and whipped up some delectable muffins, with a smooth, savory gravy that packs quite a punch! No one will be calling these toad muffins stale.

Level: ▭▮▮▮▯▯▯ ◇

Prep Time: 30 minutes

Inactive Time: 4 hours

Cook Time: 1 hour

Yield: 12

Dietary Notes: N/A

Cuisine: Redguard

Equipment: Muffin tin

TOAD MUFFINS

1 cup all-purpose flour

½ teaspoon kosher salt

1 teaspoon ground cumin

½ teaspoon ground cinnamon

¼ teaspoon ground cloves

3 eggs

1 cup whole milk

¼ cup peanut oil

12 precooked breakfast sausages, halved

To make the toad muffins:

1. In a medium bowl, combine the flour, salt, cumin, cinnamon, and cloves. Add the eggs and milk and whisk together until smooth. Cover and place in the refrigerator to rest for 4 hours.
2. Preheat the oven to 425°F.
3. Prepare a muffin tin by filling each hole with 1 teaspoon of peanut oil. Add a sausage half to each hole. Place in the oven and bake for 10 minutes, to heat up the sausage.

Note: I recommend placing a baking sheet under the muffin tray to help avoid spilling any of the oil as you are working with this. Better to be safe and keep a clean working area!

4. Remove the tray from the oven and quickly pour the batter into each of the holes, about three-quarters of the way up. Return to the oven and bake for another 15 to 20 minutes, or until the muffins have puffed up and are golden brown.

Recipe continues on page 30.

Recipe continued from page 29.

GRAVY

1 tablespoon olive oil

1 onion, thinly sliced

Kosher salt

1 tablespoon duck fat

2 tablespoons all-purpose flour

1½ cups chicken broth

1 teaspoon Worcestershire sauce

3 tablespoons harissa paste

Kosher salt

Ground black pepper

To make the gravy:

1. In a medium pan, heat the olive oil over medium heat. Add the onions and toss to coat with the oil. Cook the onions until translucent, about 2 minutes.

2. Add a pinch of salt, stir, and reduce the heat to medium-low. Continue cooking and stirring occasionally until the onions become golden and caramelized, 30 to 45 minutes.

3. Add the duck fat. Once melted, slowly add the flour while constantly whisking.

4. Continue stirring until the roux is toasted to a tan color and smells nutty. Slowly add the broth, Worcestershire sauce, and harissa. It is very important that you do this slowly while constantly whisking. This will allow the gravy to become nice and thick. Bring to a boil and then reduce the heat to simmering.

5. Simmer until the gravy has thickened. Season with salt and pepper to taste. Keep warm until serving.

To assemble and serve:

1. Carefully remove the toad muffins from the tray and serve immediately with the gravy. This is best enjoyed the day it is made.

ORZORGA'S TRIPE TRIFLE POCKET

This is a re-creation I'm particularly proud of, for its connection to my people and for being the first historic recipe I ever brought to the present! At some point in my childhood, one of my father's friends brought a small chest to Mor Khazgur, a chest full of Orsimer artifacts he'd won back from Breton soldiers. One of these bygone heirlooms was a book that detailed a wondrous feast held at the Orsinium in the Second Era—and one of the dishes recorded was an interesting package-esque pasty. I spent weeks racking my brain over just how to balance the taste. When I finally got it right, it became a favorite among those at Mor Khazgur. I've adjusted the recipe here to be friendly to all peoples, but the name of the recipe is still a tribute to the fierce commander-turned-chef who created it.

Level: ◁▭▭▭▭▷
Prep Time: 30 minutes
Inactive Time: 30 minutes
Cook Time: 45 minutes
Yield: 6 pastries
Dietary Notes: N/A
Cuisine: Orsimer

FILLING

1 pound chicken gizzards

1½ teaspoons kosher salt, divided

½ teaspoon ground black pepper

⅓ cup soy sauce

¼ cup mirin

1 teaspoon sake

1 tablespoon dark brown sugar

2 teaspoons ginger powder

1 teaspoon garlic powder

1 tablespoon olive oil

5 scallions, white and light green
 parts only, chopped

2 shiitake mushrooms, chopped

To make the filling:

1. Prepare the gizzards by cutting off and discarding the white part, then place the red meaty part in a medium bowl. Sprinkle 1 teaspoon of salt over the reserved chicken gizzards and rub together. Let sit for 5 minutes.

2. Thoroughly rinse the chicken gizzards, then chop them into smaller pieces and set aside. In a small bowl, whisk together the remaining salt, pepper, soy sauce, mirin, sake, brown sugar, ginger powder, and garlic powder.

3. In a medium nonstick pan, heat the olive oil over medium-high heat. Add the chicken gizzards and sauté until the color changes from pink to brown, about 3 minutes. Add the scallions and shiitake mushrooms and cook until lightly browned, 8 to 10 minutes.

4. Add the sauce mixture, toss, and cook until the liquid has evaporated, about 5 minutes. Remove from the heat and set aside.

Recipe continues on page 34.

Recipe continued from page 33.

ASSEMBLY

4 eggs

Nonstick cooking spray, for greasing the pan

½ cup shredded mozzarella cheese

2 sheets frozen puff pastry, defrosted

To assemble:

1. In a medium bowl, whisk together the eggs. Grease a pan with cooking spray and heat over medium heat.
2. Add the egg mixture and whisk vigorously. Stop and let cook for 30 seconds. Continue to whisk together. When the eggs are about done and scrambled, add the mozzarella, mix, and cook until melted. Transfer to a medium bowl.
3. Add the cooked chicken gizzards to the bowl and toss until well mixed. Set aside.
4. Preheat the oven to 350°F. Line a large baking sheet with parchment paper.
5. Take each of the puff pastry sheets and split them into three long portions; you should end up with six strips.
6. Take one of the strips and place one-sixth of the egg filling on the bottom half. Fold the top half over it to cover the filling. Use a fork to seal the pastry closed. Transfer to the prepared baking sheet and cut two small holes on the top. Repeat this step with the remaining puff pastry strips and filling.
7. Once all the pockets have been put together, place in the oven and bake for 20 to 25 minutes, until the puff pastry is cooked through.
8. Increase the heat of the oven to 425°F and bake for 2 to 5 minutes, or until golden brown. Remove from the oven and let cool for 5 minutes before serving.

Note: Keep a close eye on these pastries while they bake—they can easily burn.

RAJHIN'S SUGAR CLAWS

I often spent the new year on the road during my journey. One of these times, I was lucky enough to come across a few travelers from Elsweyr. They'd struck up a spontaneous New Life Festival and welcomed me to their campfire. I cooked them a Khazgur-style Stonetooth Bash Chicken (page 131)—I suppose I was slightly homesick! In exchange, they tried to teach me how to properly nick coins for their traditional Trial of Five-Clawed Guile, and the next morning, they made me a breakfast pastry paying homage to Rajhin. I made a terrible thief, but I think I've done a decent job re-creating the recipe here.

Level: ◁▮▮▮───▷
Prep Time: 30 minutes
Inactive Time: 30 minutes
Cook Time: 15 minutes
Yield: 12
Dietary Notes: Vegetarian
Cuisine: Khajiit

FILLING

3 tablespoons black sesame powder

1 tablespoon ground cinnamon

2 teaspoons ground cardamom

2 tablespoons light brown sugar

Pinch kosher salt

SUGAR CLAWS

2 puff pastry sheets, thawed

2 tablespoons unsalted butter, melted and cooled

1 egg yolk

1 tablespoon amaretto

2 teaspoons sugar

2 teaspoons black sesame

½ teaspoon ground cinnamon

To make the filling:

1. In a small bowl, combine black sesame powder, cinnamon, cardamom, brown sugar, and salt. Set aside.

To make the sugar claws:

1. Line a large baking sheet with parchment paper. Set aside.
2. Take each puff pastry sheet and cut into three equally long strips.
3. Take one of the strips and lay it in front of you horizontally. Brush the sheet with butter, leaving a ½-inch border around the edge.
4. Generously top with the filling and lightly press it in. Take the bottom of the puff pastry and tightly roll it up, pinching the ends shut. Cut the roll in half, making two portions.
5. Take one of the portions and cut five slits, one-third of the way in, on one of the edges. Transfer to the prepared baking sheet, making sure to curve the pastry slightly to keep the cuts separated. Leave about 1 inch of space around each pastry. Repeat this step with the other half of the pastry roll.
6. Repeat steps 3 to 4 with the remaining sheets and filling. You should end up with 12 pastries.
7. Place the baking sheet in the freezer and let rest for 30 minutes.
8. Preheat the oven to 400°F.
9. In a small bowl, whisk together the egg yolk and amaretto. In another small bowl, combine the sugar, black sesame, and cinnamon.
10. Brush each of the pastries with the egg mixture and sprinkle with the sugar mixture. Bake for 12 to 15 minutes, or until golden brown.

Recipe continues on page 38.

Recipe continued from page 37.

GLAZE

1 tablespoon unsalted butter, melted

½ cup powdered sugar

Pinch kosher salt

1 teaspoon vanilla paste

2 tablespoons milk

To make the glaze:

1. While the pastries are baking, in another small bowl, whisk together the butter, powdered sugar, salt, vanilla paste, and milk until smooth.

2. Once the pastries are done baking, let them rest for 5 minutes before drizzling the glaze over them. Serve warm.

APPETIZERS

APPETIZERS

◆

Early on in my travels, I came to appreciate the luxury of a good appetizer. Moving from village to village, I was occasionally invited to eat at well-stocked tables, though they were nowhere near the wealth and luxury that my mentor was used to. These were valuable occasions: I cherished the ability to munch on Kollopi or Elsweyr Corn Fritters a lot more once I had experienced near starvation on the road, eating toasted ants to sate my empty stomach. Appetizers came to signify abundance and anticipation, a lovely reminder that a full stomach was guaranteed.

I arrived at Skingrad's gates hoping for the promise of a full stomach, for I'd been on the road too long for my liking. Skingrad is renowned for their beautiful tomato vines and perfectly ripened cheeses and is a city that always comes up in discussions of fine dining. I was not disappointed: After a few days, I caught wind of a "luxury cuisine competition" that was to occur the next Loredas. All chefs were invited to participate, and the prize was to be a set of kitchen tools more opulent than

I had ever seen: pots made of polished steel, spatulas inlaid with gold filigree! There was nothing to lose by entering, I believed.

I soon discovered that I was wrong: I was quickly losing my sanity. It turned out that "all chefs" really meant that my competition were all culinary chefs from various expensive backgrounds. They each certainly had a hundred times more experience than I when it came to fine dining and high cuisine. Meanwhile, I was low on funds and had to negotiate a cheap rate at an already declining inn. Every day leading up to the competition, I borrowed the inn's kitchen, practicing rigorously and fretting to the innkeeper, an elderly woman named Emeloria.

"If only I had that prize already! Surely, the other chefs all have new cookware to use for this competition. Those beautiful supplies are nothing to them—this is all a show to them!"

"Perhaps they're chasing riches of other kinds, dear. Here, have some chips—you must keep your energy up!"

Day after day, I wolfed down fried pita chips and worked on which courses made me seem the most highbrow, which courses would speak to the judges' expensive tastes, how to decorate my plates in the most attractive way. Emeloria had endless patience for me, but on Fredas morning I was still unsatisfied with my appetizer.

"I don't understand why, but this dish just doesn't feel right." I slid my dish, some concoction of blue dartwing and various drizzles, across to Emeloria and tugged the bowl of chips closer to myself.

"Hmm." Emeloria sampled the wing thoughtfully. "I think I know your problem, dear. This is wonderful, of course, and I've never had anything like it before, but, as an appetizer, it doesn't . . . how do I put this? It doesn't make me want more."

She was right—that was exactly it. I hung my head and groaned into the bowl of chips. I had one day to find a whole new appetizer. Something that would make the judges want more, not satisfy them immediately. But where was I going to find that?

I stared into the bowl. "Emeloria, how do you normally serve these?"

"The pita chips? Oh, I used to fry them up before dinnertime and put out a few bowls so that guests could snack a bit. Got everyone nice and peckish. Those were the days before my husband ran off with my savings, bless him."

"Will you teach me how to make them?"

Those fried chips, something Emeloria first cooked up out of stale pita, won the judges' hearts and stomachs! Though it turned out that I hadn't needed to sweat so much: most of my competitors had shiny tools but not much actual skill. I won the fancy cookware with ease, but holding my silver-inlaid frying pan . . . I found myself missing the weight of the one my brother had forged for me.

I left the new set with Emeloria—it was too much to carry on the road, anyway! Last I heard from her, she's sold some of it to fix up her inn and uses the rest of the set to fry pita chips and blue dartwings.

ALIK'R BEETS WITH GOAT CHEESE

I was particularly excited to explore the various ruins of the Alik'r Desert. Ruins of ancient civilizations were the subject of my boyhood dreams! Once turned from dream to real life, though, the reality of the harsh desert sun nearly did me in. I frequently imagined bandits on the horizon, only to blink the mirages out of my eyes. The nights were worse, if possible—I nearly froze to death one night, had I not stumbled upon a kind man named Rissan and his herd of goats. I must've scared him out of his wits, dragging myself up to him like a zombie! Fortunately, my chattering teeth didn't prevent me from asking for help, and he had a warm goat-fur blanket to spare. Rissan and I are still pen pals—he sent me this petite recipe to include for the collection.

Level:
Prep Time: 1 hour
Cook Time: 50 minutes
Inactive Time: 2 hours
Yield: 10 mini towers
Dietary Notes: Vegetarian
Cuisine: Redguard
Equipment: 1-inch round cookie cutter

3 red beets

3 golden beets

½ ounces watercress, chopped

GOAT CHEESE FILLING

4 ounces goat cheese

1 teaspoon fresh dill, finely chopped

1 tablespoon chives, finely chopped

1 teaspoon fresh mint, finely chopped

1 teaspoon lemon zest

2 teaspoons lemon juice

2 teaspoons olive oil

Pinch kosher salt

Black ground pepper

1. Place the different beets in two separate medium pots with water over high heat. Bring to a boil, reduce the heat to medium, and simmer until the beets are tender (and can be pierced with a toothpick easily) all the way through, 45 to 50 minutes.

Note: Make sure to put the beets in two different pots to avoid the red ones dying the golden ones. I'd also recommend wearing plastic gloves to avoid dying your hands while preparing this dish.

2. While the beets are cooking, in a medium bowl, combine the goat cheese, dill, chives, mint, lemon zest and juice, olive oil, salt, and pepper. Mix together until completely incorporated. Cover and place in the refrigerator until you are ready to use it.

3. Drain the beets and let cool before peeling and discarding the skin. Thinly slice the beets into ½-inch-thick slices. Use a 1-inch-diameter round cookie cutter to cut out small rounds in each of the slices. Try to get between 20 to 30 small rounds of these from each color.

4. To set up these snacks, take either a red or golden beet round and top with a small amount of the goat cheese spread. Top with a golden beet, followed by another dollop of the goat cheese spread. Top with another red beet round and a small amount of the goat cheese spread. Finally, top with the watercress. Repeat until all the beets have been used.

Note: If you have extra goat cheese spread, this goes really well on a sandwich!

5. Transfer to an airtight container, cover and chill in the refrigerator for at least 2 hours before serving.

FALINESTI FORBIDDEN FRUIT

There is nothing as fantastic to an imaginative child than *Falinesti*. A walking city of leaf and branch, roving Valenwood, disappearing and reappearing throughout history? I couldn't resist seeking it for myself in Valenwood. Records speak of the city as truth, not just myth, but I could not track Falinesti's whereabouts to a current location. I did, however, learn how to cook this delicious recipe—which you may be surprised to learn has Bosmeri origins, considering its green contents! While reading about Falinesti, I learned that many of its inhabitants would break the Green Pact, supplementing their meat diets with veggies. I do wonder if breaking the pact could have something to do with the city's disappearance . . .

Level:

Prep Time: 30 minutes
Yield: 2 servings
Dietary Notes: Gluten-free, vegetarian
Cuisine: Bosmer

2 ounces radish, sliced

2 ounces kalamata olives, halved

2 ounces red onion, sliced thinly

3 ounces crumbled feta cheese

10 fresh mint leaves, sliced thinly

14 ounces watermelon, cut into bite-size pieces

1½ tablespoons olive oil

2 teaspoons balsamic vinegar

1 teaspoon lemon zest

Pinch kosher salt

3 ounces spinach, chopped

3 ounces arugula, chopped

1. In a medium bowl, combine the radish, olives, red onion, feta cheese, and mint leaves. Toss the watermelon in the bowl. Add the olive oil, balsamic vinegar, lemon zest, and salt and toss until coated. Season with additional salt if needed.

2. Mix the spinach and arugula and split between two bowls. Top with the watermelon mixture.

GOLD COAST MUDCRAB FRIES

One unexpected side effect of the Great Anguish of the Third Era is the boom of seafood, especially along the Gold Coast. I learned this from a wealthy man in Anvil who, upon learning of my connection to the Gourmet, invited me to dine with his family. His ancestors had been farmers in the Cyrodiil countryside but had fled in hopes of escaping the Daedra. They opened a mudcrab restaurant just in time for refugees to flock to the Gold Coast. The restaurant performed spectacularly based on rumors that mudcrab meat repelled Daedra! I have never found any confirmation that any sort of seafood has Daedric-repelling tendencies, so I wonder whether my host's ancestors might have spread those themselves.

Level: ▭▭▯▯▯
Prep Time: 45 minutes
Inactive Time: 1½ hours
Cook Time: 3 to 4 minutes per batch
Yield: 12
Dietary Notes: N/A
Cuisine: Imperial

MELON SAUCE

1 pound honeydew
2 shallots, halved
1 jalapeño, halved
1 garlic clove
1 tablespoon sugar
½ teaspoon kosher salt
¼ cup cilantro
1 tablespoon lime juice
1 tablespoon white vinegar
⅓ cup sour cream

CRAB CROQUETTES

3 tablespoons unsalted butter
2 shallots, diced
2 tablespoons all-purpose flour
1 teaspoon garlic powder
1 teaspoon ground fenugreek
1 teaspoon kosher salt
1 teaspoon ground black pepper
1 russet potato, peeled, cooked, and mashed
1 sweet potato, peeled, cooked, and mashed
1 pound crabmeat
1 cup all-purpose flour
3 eggs
2 cups panko
Neutral oil (such as peanut or canola), for frying

To make the melon sauce:

1. In a food processor, pulse the honeydew, shallots, jalapeño, garlic, sugar, salt, cilantro, lime juice, vinegar, and sour cream until all the ingredients are well combined and smooth. Transfer to an airtight container, cover, and place in the refrigerator until ready to serve. The melon sauce can be stored for up to 1 week.

To make the crab croquettes:

1. In a large skillet, heat the butter over medium-high heat. Once melted, add the shallots and cook until translucent, about 5 minutes. Add the flour, garlic powder, fenugreek, salt, and pepper. Mix until well combined. Remove from the heat and mix in with the mashed potatoes.

2. Mix in the crabmeat until well combined. Split the mixture into 12 equal portions. Form into 4½-inch-long rectangular blocks and place on a tray with parchment paper. Freeze, uncovered, for 40 minutes. Transfer to the refrigerator for 40 minutes.

3. Prepare three stations for breading the croquettes. The first station has a plate of flour, the second is a bowl with the eggs lightly beaten, and the final station is a plate of panko. Coat each patty in flour, followed by the eggs, and finally in the panko. Place the coated croquettes back into the refrigerator while heating the oil.

4. Place 2 inches of peanut oil in a deep pot and heat to 375°F. Carefully place several of the croquettes at a time into the heated oil. Cook each for 3 to 4 minutes, until golden. Repeat until all the croquettes are cooked.

KOLLOPI

In the early days of my education, there were a few books that the Gourmet insisted were required readings for any budding chef. The most important of them was The Red Kitchen Reader by Simocles Quo, one of the foremost voices in cuisine during the Third Era. Balagog would quiz me on Quo's words as I sweat over the stove: Where had Quo caught Merringar? Which seasoning did he recommend with Nordic barnacles? What was his technique for the perfect sweetroll? I think fondly of those nights as I make this dish, one of both Quo's and Balagog's favorites, and I remember another wise quote from the Reader: "Much of the pleasure of a great meal is not only in the food: it is in the setting, the company, the mood."

Level:
Prep Time: 30 minutes
Cook Time: 30 minutes
Yield: 12 to 14 meatballs
Dietary Notes: N/A
Cuisine: Bosmer

MEATBALLS

1 tablespoon unsalted butter

1 shallot, chopped

2 garlic cloves, minced

1 pound ground wild boar

⅓ cup panko

1 egg yolk

½ teaspoon kosher salt

½ teaspoon ground black pepper

1 teaspoon ground fennel

1 teaspoon ground coriander

1 tablespoon canola oil

GRAVY

3 tablespoons unsalted butter

¼ cup all-purpose flour

2 cups chicken broth

½ cup sour cream

½ cup heavy cream

2 teaspoons Dijon mustard

1 teaspoon Worcestershire sauce

Kosher salt

Ground black pepper

To make the meatballs:

1. In a small saucepan, heat the butter over medium-high heat. Once the butter has melted, add the shallots and cook until just softened, about 5 minutes. Add the garlic and cook for another 2 minutes. Remove from the heat and place on a plate lined with a paper towel to drain the excess butter. Let cool completely.

2. In a large bowl, combine the ground wild boar, panko, egg yolk, salt, pepper, fennel, coriander, and cooled shallots and garlic. Stir together until just combined. Form the mixture into 1½-inch meatballs. You should end up with about 12 to 14 meatballs.

3. In a large skillet, heat the canola oil over medium-high heat. Add the meatballs, brown each side, and cook through, about 10 to 15 minutes. Transfer to a plate.

To make the gravy:

1. In the same pan, melt the butter over medium-high heat. Slowly add the flour.

2. Continue whisking until the roux is toasted to a tan color and smells nutty. After the butter and flour have combined into a roux, slowly add the broth. It is very important that you do this slowly while constantly whisking. This will allow the gravy to become nice and thick.

3. Bring to a boil and then reduce the heat to medium-low. Simmer until the gravy has thickened.

4. Whisk in the sour cream, heavy cream, Dijon mustard, and Worcestershire sauce. Season with salt and pepper to taste. Stir the meatballs into the gravy and simmer for 5 minutes until the meatballs are heated up. Serve immediately.

CARAMELIZED GOAT NIBBLES

Walking through the Sentinese Bazaar is a true dream for any chef. The fragrant aroma of their marinades had me stopping at every stall! I sampled many delicious foods, but these nibbles were a standout. The game, so delightfully caramelized, pairs beautifully with the succulence of grilled vegetables. This dish was my go-to while staying in Sentinel.

Level:
Prep Time: 45 minutes
Inactive Time: 12 hours
Cook Time: 10 minutes
Yield: 7 skewers
Dietary Notes: Dairy-free, gluten-free
Cuisine: Redguard
Equipment: Skewers, grill pan

¼ cup olive oil

2 tablespoons dried oregano

1 tablespoon ground cumin

1 tablespoon garlic powder

2 teaspoons ground coriander

1 teaspoon ground ginger

1 teaspoon ground fenugreek

1 teaspoon kosher salt

½ teaspoon Kashmiri chile powder

2 pounds goat leg, cubed

½ red onion

14 cherry tomatoes

2 green peppers, cut into small portions

Note: Kashmiri chile powder can be subbed with paprika and a small pinch of cayenne.

1. Preheat a grill to high heat.
2. In a large airtight container, combine the olive oil, oregano, cumin, garlic powder, coriander, ginger, fenugreek, salt, and Kashmiri chile powder. Add the goat and toss to coat. Seal and place in the refrigerator overnight.
3. The next day, place seven wooden skewers in water to soak for 30 minutes prior to grilling. Remove the goat from the marinade. Place two pieces of meat on a skewer, followed by three pieces of red onion, a tomato, and a slice of green pepper. Repeat this again. Finish the skewer by topping with another two pieces of goat meat. Repeat this with the remaining skewers until all the ingredients are used.
4. Cook the skewers for 7 to 10 minutes on the grill, flipping to crisp all sides and cook the goat through. Serve immediately.

TROLL FAT JERKY

Orsimer have employed troll fat since before our records start, but even knowledge of its many uses can't chase away the fact that it is entirely unappetizing in its raw form. In the cold winters, we would always take some Troll Fat Jerky into the mines, keeping us energized and warm. It was purely functional and lacked taste. Until, of course, I began experimenting with it. The robust spiced marinade I've added to this recipe has turned troll fat from something that hungry travelers refuse to a delicacy lauded by even the highest tables I've supped at.

Level:
Prep Time: 30 minutes
Inactive Time: 24 hours
Cook Time: 5 hours
Yield: 10 servings
Dietary Notes: Dairy-free
Cuisine: Orsimer

½ cup soy sauce

½ cup maple syrup

¼ cup Worcestershire sauce

2 tablespoons Chinese five-spice powder

1 tablespoon ground black pepper

2 pounds duck breast, skin and fat removed and thinly sliced

Nonstick cooking spray, for greasing the wire rack

1. In a gallon-size zip-top bag, combine the soy sauce, maple syrup, Worcestershire sauce, Chinese five-spice powder, and pepper. Add the duck, seal, and shake until the duck is covered in the marinade. Place in the refrigerator overnight to marinate, up to 24 hours.
2. Preheat the oven to 175°F. Line a baking sheet with aluminum foil, place a wire rack on top, and spray with cooking spray.
3. Take the duck out of the marinade and let the excess liquid drip off. Place on the wire rack. Cook in the oven for 4 to 5 hours or until the duck is dry and chewy. Let cool completely.
4. Store in an airtight container in the refrigerator for up to 1 week.

ELSWEYR CORN FRITTERS

I learned this recipe from Balagog, who learned it from a friend named Lorawen, who learned it from a friend named Saashi. It comes with a story of hope, of different races coming together to rebuild a town. Or at least Balagog said it did—he couldn't remember most of the story, though he remembered that Saashi had an irritating cousin. Some details stick better than others! And I'm certain this recipe will stick with you.

Level: ▯▮▮▮▯
Prep Time: 30 minutes
Inactive Time: 30 minutes
Cook Time: 10 minutes per batch
Yield: 9 servings
Dietary Notes: Vegetarian
Cuisine: Khajiit

CORN FRITTERS

3 cups corn kernels

3 scallions, chopped

½ cup cheddar cheese, shredded

½ cup all-purpose flour

¾ cup cornmeal

1 teaspoon baking powder

1 teaspoon kosher salt

1 tablespoon honey

1 egg

½ cup milk

1 tablespoon canola oil

GRAPE SAUCE

½ cup sour cream

2 tablespoons grape jelly

1 tablespoon sugar

Pinch kosher salt

To make the corn fritters:

1. In a medium bowl, combine the corn, scallions, cheddar, flour, cornmeal, baking powder, salt, honey, egg, and milk and mix until smooth. Set aside and let rest at room temperature for 30 minutes.
2. In a large nonstick pan, heat 1 tablespoon of canola oil over medium-high heat. For each patty, scoop a ½ cup of the mixture and form into a patty in the pan, but do not overcrowd the pan. Cook each side until golden brown, about 2 to 4 minutes. Serve warm with the grape sauce.

To make the grape sauce:

1. In a small bowl, whisk together the sour cream, grape jelly, sugar, and salt. Transfer to an airtight container, cover, and place in the refrigerator until ready to serve. The grape sauce can be stored for up to 1 week.

SINGING TUBER SALAD

Speaking of required books, I stumbled upon this recipe while reading the words of Castus Marius, who wrote of their experience with druid-grown food while traveling Galen. Although I was never able to find the vegetable "chimera" hybrid known as "Singing Tuber," I was able to approximate the dish using nirnroot, leek, and carrots. The outcome indeed proved light, crunchy, and bold, though thankfully I seem to have avoided the sensation of ringing sunset colors.

Level: ◁▯▯▯▷
Prep Time: 30 minutes
Inactive Time: 20 minutes
Cook Time: 1 hour
Yield: 6 servings
Dietary Notes: Vegetarian
Cuisine: Breton

MOON-SUGAR VINAIGRETTE

¼ cup apple cider vinegar

2 tablespoons granulated sugar

2 tablespoons dark brown sugar

1 teaspoon garlic powder

1 teaspoon Dijon mustard

⅔ cup olive oil

Kosher salt

Ground black pepper

SALAD

2 golden beets

2 tablespoons olive oil, divided

Kosher salt

Ground black pepper

3 purple carrots, peeled and cut into thick slices

2 white carrots, peeled and cut into thick slices

8 ounces arugula

8 ounces spinach

2 ounces pecans

4 ounces blue cheese

To make the moon-sugar vinaigrette:

1. In a small bowl, combine the apple cider vinegar, granulated sugar, brown sugar, garlic powder, and Dijon mustard. Whisk in the olive oil and season with salt and pepper to taste.
2. This dressing can be stored in an airtight container in the refrigerator for up to 1 week. The oil and acid will separate after sitting for a while, so make sure to shake vigorously before serving.

To make the salad:

1. Preheat the oven to 400°F.
2. Rub the beets with 1 tablespoon olive oil. Generously season with salt and pepper. Take one of the beets and place it on a sheet of aluminum foil and wrap it shut. Repeat with the remaining beets.
3. Place the aluminum-wrapped beets on a baking sheet. Transfer to the oven and roast for 45 to 60 minutes, until tender.
4. When the beets have 20 minutes left, toss the carrots in the remaining 1 tablespoon olive oil. Transfer to a baking sheet and season with salt and pepper. Place in the oven and cook for the remainder of the time or until slightly crispy.

Note: If the carrots finish before the beets, just remove them from the oven and set them aside.

5. Allow the beets to cool before peeling and discarding the skin. Thinly slice the beets into ¼-inch-thick pieces. The sliced beets can be stored in an airtight container in the refrigerator for up to 1 week.
6. To prepare the salad, in a large bowl, combine the spinach and arugula and toss until well mixed. Divide the greens among six salad bowls. Top each with the roasted beets, carrots, pecans, and blue cheese. Serve with the Moon-Sugar Vinaigrette.

THE HOUND AND RAT

I first had this sumptuous Redoran dish at a tavern in Morrowind. The tavern chef had a playful streak, and she waited until I had finished the entire thing to tell me that the name of the dish was a literal description! I'm sure she saw my face turn as my stomach did, because she then quickly clarified that contemporary chefs exclude both hound and rat meat for more "cultured" tourists. After thinking about it, though, perhaps the tourist who balks at another race's traditional foods is the one in need of culture.

Level: ▢▢▢
Prep Time: 1 hour
Inactive Time: 30 minutes
Cook Time: 1 hour
Yield: 12 hand pies
Dietary Notes: N/A
Cuisine: Dunmer
Equipment: Muffin tin

◆

1 tablespoon olive oil

1 onion, diced

4 garlic cloves, diced

1 pound ground lamb

1 tablespoon sumac

2 tablespoons parsley, chopped

1 teaspoon ground cinnamon

½ teaspoon ground allspice

½ teaspoon ground Kashmiri chile powder

1 teaspoon kosher salt

8 ounces halloumi cheese, chopped into small cubes

2 puff pastries, thawed

Nonstick cooking spray, for greasing the muffin pan

1 egg, whisked

Note: Kashmiri chile powder can be subbed with paprika and a small pinch of cayenne.

1. In a large nonstick pan, heat the olive oil over medium-high heat. Add the onion and cook until softened, about 8 minutes. Add the garlic and cook for another 2 minutes.

2. Add the lamb and cook until browned, 5 to 8 minutes. Add the sumac, parsley, cinnamon, allspice, Kashmiri chile powder, and salt and mix until everything is fully coated. Continue to cook until the lamb is cooked through, about 5 minutes.

3. Remove from the heat and toss in the cheese until well mixed. Transfer to a mesh strainer to drain excess liquid and set aside until fully cooled.

4. Lightly roll out the puff pastry sheets. Using a 4-inch round cookie cutter, cut 12 circles for the base. Using a 3-inch round cookie cutter, cut out 12 circles for the top. Cover these rounds with a kitchen towel to keep them from drying out.

5. Preheat the oven to 400°F. Grease a muffin pan with cooking spray.

6. Place the larger pieces of puff pastry inside each of the holes in the muffin pan and lightly press them down.

7. Fill each of the puff pastries with the lamb filling, but do not overfill. Place the remaining puff pastry circles on top and press the edges shut. Place in the freezer and let rest for 30 minutes.

8. Remove the muffin tin from the freezer. Brush the top of each of the muffins with egg. Place in the oven and bake for 25 to 30 minutes, or until the tops are golden brown.

9. Remove from the oven and let rest for 5 minutes before removing from the pan and serving.

BREAD

BREAD

◆

I came first to the Imperial City with a goal: Learn how to bake a decent loaf of bread.

If you've ever tried to bake a loaf of bread, any kind of loaf, you know: bread is involved, bread is finicky, and bread is difficult, notoriously so. Two bakers can follow the same instructions exactly and turn out entirely different loaves. Baking was always daunting to me and tested my patience. Out on the road, unsure when I'd have my next meal, preparing and baking bread only to fail meant wasted energy, time, and ingredients. In the city, I had slightly more leeway—and if I was going to be a cook worthy of my mentor, I had to be able to bake bread.

I began this arduous task by shopping. Day after day, I would return to the Market District, trying to calculate ingredients that would grant me success. In hindsight, I do feel I was stalling, for a full week of indecision had passed before I was semi-certain of even which flour to buy. I went to purchase it, only to reach into my pocket and discover that my purse had been stolen.

The horror! I had to sit down outside the walls of the Market District to properly grasp my misfortune. With

no gold, how could I buy shelter, services, and most of all, ingredients? My education had been cut short. When I had run through my options again and again and finally given up, a shadow fell over me.

It was a Khajiit, looking down at me with some pity. She introduced herself as Tsaltima, a traveling entrepreneur—she had seen me downcast and wondered why. I explained my rotten hand, and to my immense gratitude, Tsaltima offered to buy my ingredients if I would let her have some of the results of my experiments.

Here I must pause and explain something about myself, that you may have been able to guess already: I've never had the easiest time making friends. Like baking the perfect loaf of bread, friends have seemed to elude my grasp. While traveling, I spent a lot of time with new people, and I treasure those memories, but most of the folks I met were only fleeting acquaintances once we said our goodbyes. Back at the stronghold, though I had earned respect, I think they still had a hard time relating to me. I have a tendency to ramble if I'm nervous, which I often am, or when I'm passionate,

which I often am. And people didn't want to hear about my cooking—they just wanted to eat it. To be clear, I don't blame them. We just didn't have the same interests.

So it was strange, to walk about a city and buy ingredients with a peer. Tsaltima was off-putting—it was hard to follow her thought process with how fast she bounced from subject to subject. She talked about her business ventures, things that she was looking to invest in. She made alarming allusions to things she'd done, places she was no longer allowed to go. She also asked questions as I gathered, then prepared, my ingredients: first about cooking, then about me, my family, my journey. Eventually, I admitted to her something I hadn't said yet to anyone else:

"I've been thinking—well, imagining only—about what it might be like to write a book."

"Tsaltima believes you should write a book of all your breads and fine cookings!"

"That's it exactly! But I'm not sure I could do it."

"Of course you can. You are already doing it! This one knows, you are afraid of danger, yes? Tsaltima will travel with you now and then to keep you safe."

"That's . . . actually very kind of you, Tsaltima. I mean, it'd be nice to travel alongside someone. But really, who am I to tell others how to cook? I'm only learning, myself. There's no reason anyone should be interested in what I have to say. And regardless, I have no money to get me home, let alone publish a book."

"Ah, do not fret there, my friend, on either account! You are interesting enough for Tsaltima, you are interesting enough for Tamriel. So much so that this one shall be your first investor." And she tossed me my own stolen purse.

I mentioned before that bread takes a long time; this loaf needed a full day from start to finish. But before I knew it, the hours were up and the bread was ready. I can't lie, it was only mediocre—but the experience changed my perspective on both bread and friendship.

Bread takes time, effort, and energy. Bread is difficult and involved. Bread is unique. And that's what makes it wonderful.

I met Tsaltima. I baked a decent loaf of bread. And I decided to write this book.

COMBWORT FLATBREAD

One look, sniff, or taste of this flatbread will tell you that it originates from the Starry Heart of Nirn. Cyrodiil professes itself the first place that baked bread, but this is not a unique claim: Many Mer declare that bread was born in Alinor. In truth, I suspect that bread was born in many places in many forms, and that even history cannot tell us which was first.

Level:
Prep Time: 30 minutes
Inactive Time: 2 hours
Cook Time: 20 minutes
Yield: 1 loaf
Dietary Notes: Vegan
Cuisine: Breton

2¼ teaspoons active dry yeast

2 teaspoons sugar

3 tablespoons olive oil, plus more for brushing

1⅓ cups lukewarm water

2 cups all-purpose flour, plus more for dusting

2 cups bread flour

2 rosemary sprigs, chopped

1 tablespoon kosher salt

30 cherry tomatoes, halved

Sea salt flakes

1. In a large bowl, combine the yeast, sugar, olive oil, and water. Let rest for 5 minutes or until the yeast becomes active. Add the all-purpose flour, bread flour, rosemary, and salt and mix until it just comes together. Transfer to a lightly floured surface and knead for 5 minutes. Shape into a ball.

2. Brush a large bowl with olive oil and place the dough in it. Brush the top of the dough with olive oil. Cover and let the dough rise until it has doubled in size, about 1 hour.

3. Prepare a 15-by-10-inch baking sheet by brushing it with olive oil and then sprinkling it with sea salt flakes. Transfer the dough directly onto the baking sheet. Carefully spread the dough until it completely covers the baking sheet. If the dough seems to be too resistant to spreading, cover and let rest for 10 minutes, then continue stretching it out.

4. Once the dough is spread, cover and let rest for 15 minutes. Using your fingers, poke several deep wells throughout the dough. Lightly brush with olive oil. Add the cherry tomatoes by pushing them into the dough, cut-side up. Cover again and let rest for 40 minutes.

5. Preheat the oven to 425°F.

6. Uncover the dough and top with sea salt flakes. Bake for 18 to 20 minutes or until the top is golden brown. Remove from the oven and sprinkle with additional sea salt flakes. Let cool completely before cutting into it.

MINSTREL BANANA BREAD

Tsaltima is no baker, but even she can make this traditional Khajiit recipe, which she helped me perfect. While we baked this bread, Tsaltima would often tell me stories of her family caravanning to different lands. They kept stores of banana and flour so they could make Minstrel Banana Bread whenever they needed a reminder of home. Of course, while telling me these tales, Tsaltima would stick her thumbs in the sugar until there was none left, and I had to restock.

Level: ◁▯▮▯▯▯▷

Prep Time: 45 minutes

Cook Time: 1 hour 20 minutes

Yield: 1 loaf

Dietary Notes: Vegetarian

Cuisine: Khajiit

Equipment: 8½-by-4½-inch loaf pan

½ cup unsalted butter

Nonstick cooking spray, for greasing the pan

3 large, very ripe bananas (400 grams in total)

2 eggs

½ cup sour cream

¾ cup dark brown sugar

1 teaspoon vanilla paste

2 tablespoons olive oil

2⅔ cups all-purpose flour

½ teaspoon ground cardamom

2 teaspoons baking powder

½ teaspoon baking soda

1 teaspoon kosher salt

1. In a small saucepan, melt the butter over medium heat. Cook while occasionally swirling the butter until it becomes golden brown, about 10 minutes. Pour the butter into a cup and let it cool.

2. Preheat the oven to 350°F. Prepare a loaf pan by cutting parchment paper to cover the insides of the pan. Spray the inside of the pan with cooking spray. Place the parchment paper in the pan, pressing it against the pan until it sticks. Spray the pan again, covering the parchment paper with cooking spray. Set aside.

3. In a large bowl, mash the bananas. Add the eggs, sour cream, brown sugar, vanilla paste, olive oil, and cooled butter. Whisk together until well combined.

4. In a medium bowl, combine the flour, cardamom, baking powder, baking soda, and salt. Add the dry ingredients to the large bowl and fold in until it just comes together.

5. Transfer the dough to the prepared loaf pan and bake for 70 to 80 minutes. Let cool completely, about 2 hours, before cutting and serving. This bread can be served at room temperature or slightly warmed.

SAVORY THORN CORNBREAD

I learned of this cornbread from a fellow traveler I met: a Lukiul who wandered the edge of Cyrodiil and the Black Marsh. The original recipe, they said, was rather sparse: just corn and saltrice. Function over flavor, ideal for cooking and carrying on the road, sustenance while traveling away from the marsh. I asked the traveler how they'd come to carry the cornbread in their travels, being born and raised out of Black Marsh. "I've never lived in Black Marsh," they said. "I feel out of place with other Argonians. But I suppose I'm still looking for a way back home."

Level: ◁▢▢▢▷
Prep Time: 30 minutes
Cook Time: 45 minutes
Yield: 8 servings
Dietary Notes: N/A
Cuisine: Argonian
Equipment: 10-inch cast-iron pan

- ½ cup unsalted butter
- 1 cup cornmeal
- ⅔ cup all-purpose flour
- ⅓ cup whole wheat flour
- ¼ cup dark brown sugar
- 1 tablespoon baking powder
- 2 teaspoons kosher salt
- 2 tablespoons olive oil
- ¼ cup honey
- 2 eggs
- 1 cup buttermilk
- ½ cup sour cream
- 8 pieces bacon, chopped, cooked, and fat reserved
- 4 jalapeños, sliced
- 10 ounces cheddar cheese, grated

1. Place the bacon in a large nonstick pan, and do not overcrowd; this may need to be done in batches, Place over medium heat and cook until the bacon begins to crisp, about 4 to 5 minutes. Flip and cook until crispy, 4 to 5 minutes. Transfer the bacon to a paper towel–lined plate and the bacon fat to a heat-resistant bowl. Repeat with the remaining bacon.

2. In a small saucepan, melt the butter over medium heat. Cook while occasionally swirling the butter until it becomes golden brown, about 10 minutes. Pour the butter into a cup and let it cool.

3. Preheat the oven to 425°F. Prepare a cast-iron skillet by rubbing with the reserved bacon fat.

4. In a large bowl, combine the cornmeal, all-purpose flour, whole wheat flour, brown sugar, baking powder, and salt. In a small bowl, whisk together the melted butter, olive oil, honey, eggs, buttermilk, and sour cream. Pour the wet mixture into the large bowl. Add the bacon, jalapeños, and cheddar cheese and mix until just combined. Pour into the prepared skillet.

5. Transfer the skillet to the oven. Bake for 25 minutes. Cover with aluminum foil and bake for another 10 minutes or until cooked through. Let cool for 10 minutes before cutting and serving.

SOLITUDE BREAD

Every war throughout history has inspired—or required—people to take up new talents, including the recent civil war in Skyrim. I mentioned earlier the many Imperial troops stationed in Solitude while I was there. Well, more soldiers means more mouths to feed, and thus more hands needed to cook. This rustic loaf became very popular, probably because it's easy for new chefs to put together. Its slightly sour taste pairs excellently with all kinds of soups and stews, though if you prefer sweets, you may find it not to your tastes.

Level: ◁▭▭▭▭▭▷

Prep Time: 1 hour

Inactive Time: 24 hours

Cook Time: 50 minutes

Yield: 1 loaf

Dietary Notes: Dairy-free, vegetarian

Cuisine: Nord

Equipment: 10-inch Dutch oven with lid

POOLISH

Note: A poolish is a kind of starter that has been given time to ferment to add extra tang to the bread. This typically requires less time than a traditional sour dough starter.

½ cup bread flour

⅓ cup plus 1 tablespoon water

Pinch active dry yeast

BREAD

2 cups all-purpose flour, plus more for dusting

1¼ cups bread flour

2 teaspoons kosher salt

1½ cups warm water

2 teaspoons active dry yeast

1½ tablespoons honey

1. In a tall glass, whisk together the bread flour, water, and yeast. Loosely cover and let rest at room temperature for at least 6 hours, up to 24 hours.
2. In a medium bowl, combine the all-purpose flour, bread flour, and salt. In a large bowl, whisk together the warm water, yeast, poolish, and honey until the honey and poolish dissolve.
3. Add the flour mixture to the bowl and mix until it just comes together. The dough will be sticky and very loose at this point. Cover with a kitchen cloth and let rest for 30 minutes at room temperature.
4. Wet your hands, take the dough, lightly pull one edge of the dough to the center, and pat down. Repeat this process around the entire edge of the dough. Flip over the dough (smooth side facing up), cover, and let rest for another 30 minutes at room temperature.
5. Once again, wet your hands, pull the edges to the center, and pat down again. Flip, cover again, and rest for 1 hour at room temperature.

Note: During this stage, the dough will be extremely moist and sticky to work with, which is why your hands should be moist when working with it. This will minimize the dough sticking to your hands.

Recipe continues on page 74

Recipe continued from page 73.

6. Generously dust a work surface with flour, transfer the dough to it, and shape the dough into a ball. Place the dough on a piece of parchment paper and cover with a kitchen towel for 1 hour.

7. Preheat the oven to 425°F. Place an empty Dutch oven with a lid in the oven to preheat for 30 minutes.

8. Once the dough has risen, cut a slash across the top of the loaf.

9. Transfer the dough with the parchment paper into the preheated Dutch oven. Cover with the lid and bake for 30 minutes. Remove the lid and bake for another 10 to 20 minutes, or until the loaf is cooked. Place on a wire rack to cool completely before cutting.

VVARDENFELL ASH YAM LOAF

I was only able to view Vvardenfell from a ways off its coastline, aboard a small boat. I had asked a local to bring me, but she would not risk getting closer. I could see tears welling in her eyes and thought it might be the smog—my eyes were stinging as well—but it turned out she had lost her family in the catastrophe. I didn't know what to say. We stood there together in that boat, gazing at the Red Mountain in the distance. When we returned to safer shores, she gave me this recipe and asked that I share it with others, to memorialize something she still had.

Level: ◁▭▭▭▷
Prep Time: 1 hour
Inactive Time: 3 hours
Cook Time: 45 minutes
Yield: 1 loaf
Dietary Notes: Vegetarian
Cuisine: Dunmer
Equipment: Stand mixer with dough hook

2¾ cups plus 3 tablespoons bread flour, plus more if needed, divided

¾ cup plus 2 tablespoons milk, plus more if needed, divided

4 ounces sweet potato, cooked and mashed

2¼ teaspoons active dry yeast

1 teaspoon kosher salt

3 tablespoons sugar

3 tablespoons unsalted butter, room temperature

3 drops orange food dye (optional)

1 egg

Nonstick cooking spray, for greasing

EGG WASH

1 egg

2 tablespoons milk

1. In a small pan, heat 3 tablespoons bread flour and 2 tablespoons milk over medium-high heat. Whisk until it comes together, about 1 minute. Add the sweet potato and mix until combined. Set aside and let cool.

2. In a small bowl, combine the yeast and remaining milk and let it rest for 5 minutes. In a large bowl of a stand mixer, combine the remaining 2¾ cups bread flour, the salt, and sugar. Add the milk and yeast mixture, the orange food dye, and egg to the bowl and mix until it just comes together.

3. Knead the dough, adding 1 tablespoon butter at a time, for about 5 minutes. If the dough is too sticky, add 1 tablespoon flour at a time. If it is too dry, add 1 tablespoon milk at a time.

4. Grease a large bowl with cooking spray, cover, and let rest for 1 hour or until it has doubled in size.

5. Grease a deep loaf pan.

6. Split the dough into three equal portions. Take one of the portions and roll the dough out into a long rectangle. Make sure the width of the rolled-out portion is not wider than the baking dish you are using. Carefully roll up the dough and place it in the prepared loaf pan. Repeat with the other portions, placing each portion next to each other in the prepared loaf pan.

7. Cover and let the dough rise again for 30 minutes, or until it doubles in size.

8. Preheat the oven to 350°F.

9. In a bowl, combine the egg and milk for the egg wash. Brush the top of the bread loaf with the egg wash.

10. Bake the loaves for 15 minutes. Lightly cover each loaf with aluminum foil to avoid browning too much. Cook for another 15 to 25 minutes, until cooked through.

CANDIED NECTAR BREAD

When I think back to my time in Skywatch, a port city on the Abecean Sea, my mind immediately goes back to partaking in what the locals called "Mud Ball Merriment": a New Life Festival tradition where people pelt balls of mud at one another. The little ones in particular cackled with laughter as they fired volleys right at me. I made sure to get them back in kind, and after everyone washed up, we enjoyed a most delicious loaf of this bread. Biting into a spotted slice and getting a mouthful of sugary fruit still transports me back to that day.

Level: ◁▭▮▯▷

Prep Time: 30 minutes

Inactive Time: 3 hours

Cook Time: 1 hour

Yield: 1 loaf

Dietary Notes: Vegan

Cuisine: Altmer

Equipment: 10-inch Dutch oven with lid

2½ cups all-purpose flour

1 cup bread flour

2 teaspoons kosher salt

2 teaspoons cinnamon

1 tablespoon sugar

2 teaspoons active dry yeast

1 cup dried apricots, chopped

½ cup dried cranberries

¼ cup dried cherries

1½ cups warm water

Olive oil, for brushing

1. In a large bowl, combine the all-purpose flour, bread flour, salt, cinnamon, sugar, yeast, apricots, cranberries, and cherries. Pour in the water and mix together until the dough just comes together. If it is too sticky, add 1 tablespoon all-purpose flour at a time until it's not sticky. Lightly knead for 3 minutes.

2. Brush a large bowl with olive oil and place the dough in it. Brush the top of the dough with olive oil. Cover and let the dough rise at room temperature for 2 hours.

3. Remove the dough from the bowl, lightly knead, and shape into a ball. Place on a piece of parchment paper and cover with a kitchen towel for 1 hour.

4. Preheat the oven to 425°F. Place an empty Dutch oven with a lid in the oven to preheat for 30 minutes.

5. Once the dough has risen, cut three slashes on the top of the loaf. Transfer the dough with the parchment paper into the preheated Dutch oven. Cover with the lid and bake for 30 minutes.

6. Remove the lid and bake for another 20 to 30 minutes, or until the loaf is cooked. Place on a wire rack to cool completely before cutting.

SOUPS AND STEWS

SOUPS AND STEWS

Once word had spread about my apprenticeship to the Gourmet, I sometimes was invited to sup at high tables. It was at these tables that I began to hear the words soup and stew used as pejorative, which was perplexing to say the least. As always, I sought an answer in research and found a few leads. Arfons Jellicandante, Nibenese culinary expert, observed that labeling dishes "stew" was considered an insult. A Second Era chef named Donolon was recorded to turn his nose up at any savory dish that was served in a bowl, and more recently, the matriarch of the Black-Briar family denounced stew as "a poor man's meal."

Perhaps it's true that soups and stews are common in smaller villages and among those less wealthy. Near the border of Cyrodiil and Valenwood, I came across a small settlement. Most of the structures were run-down, but one of the houses was in good shape. A couple sat on its porch. They seemed just as surprised to see me as I was them, but they quickly approached me and introduced themselves. Hasah was a man from Dragonstar, Irrielle an elf from Firsthold. They, like me, were fans of history

who had met and fallen in love while researching the land we stood on.

Over dinner, they told me the story of the abandoned town: In the late Third Era, Turnpoint had been a small but bustling hub, fed by the natural resources of the surrounding forests and rivers. Sadly, it had been destroyed by the rise of the Thalmor. Hasah and Irrielle had settled here hoping to revitalize the town, but despite their best efforts, it seemed people avoided them. They were glad to have another face around, and I stayed for a few days, helping Hasah fix the roof of a small cottage nearby. On the final day, my finer ingredients had run out, so I threw together a stew with what I had left: just a potato, some salt, and two tomatoes in danger of drying out. Irrielle worried that their time in Turnpoint was coming to an end—soon they wanted to start a family, and they couldn't stay secluded in the woods if they wanted support.

Just as Hasah was reiterating Irrielle's concerns, a knock came at the door. It was a traveling merchant, soaked to the bone, who had seen the smoke of our

chimney. He'd smelled the savor of our stew and wondered if we could spare a bowl and some room under their roof. Hasah and Irrielle proved gracious hosts: their home was small, but their second visitor could stay in the cottage we'd just repaired. The merchant was thankful and gave them a few seeds in return—seeds to grow more stew ingredients! I left early the next morning, with Irrielle promising to write once they'd moved.

However, I happened to pass by again a while later and found that Turnpoint was not yet done for! The traveling merchant had been delighted at all the natural resources around the area and had made Turnpoint a base of his business. The seeds had sprouted and were growing quickly, with the aid of a young mage who had settled into one of two newly repaired and occupied homes. Hasah and Irrielle had kept making that same stew, and it had lured travelers in for business. Hasah was hoping to open an inn, but it was hard to find time—for Irrielle was pregnant! She craved a soup version of the stew, which I gladly made. After adding carrots, onions,

garlic, and some dried beef, I left, promising to visit again.

I didn't manage to return until the next year—and what a difference one year made! Turnpoint had grown into a full village, like it must have been in the Third Era. I stayed in Hasah and Irrielle's inn, where their sweet daughter babbled and cooed at me. There was a new town square and in its center stood a fire with an iron pot that bubbled our delicious stew! The warm, filling scent wafted all about the small town, welcoming weary travelers. With another year of experience under my belt, I was thrilled to give the stew further improvements and flavor—and take tips from the villagers of Turnpoint in return.

So yes, stews and soups may have their roots in humble villages and small towns, but that doesn't diminish their worth. In fact, I'd argue the opposite. Stew is the foundation that the hardworking folk of Tamriel build community on. Soup is the blood that ties family and friends and bridges people together! And if that's an insult, well, I'll happily take an insult any day.

ARGONIAN PUMPKIN STEW

A soup I've re-created after researching a well-respected chef of the Second Era, the appropriately named Makes-Many-Soups has numerous recipes credited to their person: Jubilee soups, soups made with mead, and soups that are celebrated all over Nirn. This rich stew, packed with flavor, is my favorite.

Level:

Prep Time: 45 minutes
Cook Time: 1½ hours
Yield: 6 servings
Dietary Notes: Dairy-free, gluten-free
Cuisine: Argonian

1 kabocha, halved and seeded

1 butternut squash, halved and seeded

1 tablespoon olive oil, plus more for brushing

Kosher salt

2 carrots, peeled and diced

1 shallot, diced

2 garlic cloves, minced

1-inch piece ginger, grated

1 lemongrass stalk

2 teaspoons Kashmiri chile powder

1 teaspoon ground coriander

3 cups Artaeum Takeaway Broth (page 87)

Juice and zest of 2 limes

13.5 ounces coconut milk

Ground black pepper

Note: If you're unable to find kabocha (Japanese pumpkin), use a small pumpkin.

ADDITIONALS

Cilantro, chopped, for topping

Scallion, chopped, for topping

Roasted pumpkin seeds, for topping

1. Preheat the oven to 375°F. Place the kabocha and butternut squash on a baking tray and brush with olive oil. Generously season with salt.
2. Place in the oven and bake for 45 to 60 minutes or until knife-tender. Set aside to let cool.
3. Once cooled, carefully peel away the skin, place the flesh on a plate, and set aside.
4. Heat 1 tablespoon of olive oil in a deep pot over medium-high heat. Add the carrots and shallots and cook until softened, about 5 minutes. Add the garlic, ginger, lemongrass, Kashmiri chile powder, and coriander. Mix together well.
5. Add the kabocha and butternut squash and broth. Bring to a boil and then reduce the heat. Let simmer for 20 minutes.
6. Turn off the heat, remove the lemongrass, and use an immersion blender or a stand blender to blend until smooth. Turn the heat back to medium and add the lime juice and zest and coconut milk. Cook until heated. Season with salt and pepper to taste. Serve topped with cilantro, scallions, and pumpkin seeds.

ARTAEUM TAKEAWAY BROTH

While visiting the Summerset Isles, we sometimes avoided or left towns for fear of locals who weren't yet on board with opening their doors to other types of people. I say "we" because I was traveling with Tsaltima, who had other reasons to stay away from law enforcement. Despite the trouble of dodging and weaving public attention, I cannot regret our travels there if only for learning the recipe for this broth, which the Aldmeri say was developed on Artaeum. I have used it as a base for many other recipes since.

Level: ◁▊▊▯▯▷
Prep Time: 15 minutes
Inactive Time: 3 hours
Cook Time: 45 minutes
Yield: 5 cups
Dietary Notes: Dairy-free, gluten-free
Cuisine: Altmer

5 cups water

2 kombu

2 tablespoons olive oil

1 onion, chopped

4 celery stalks, chopped

6 garlic cloves, smashed

1 cup dry white wine

2 pounds non-oily white fish heads and bones, rinsed and gills removed

1 cup bonito flakes

1 cup dried anchovies, head and guts removed

4 bay leaves

4 parsley sprigs

Note: Kombu is a type of dried kelp that is used to enhance the flavors of stocks. It can be stored in a cool pantry.

1. Place the water and kombu in a medium pot and cover. Let rest for 3 hours. Remove the lid and discard the kombu.
2. Heat the olive oil in another medium pot over medium-high heat. Add the onion, celery, and garlic and cook until softened, about 5 minutes.
3. Pour in the white wine and cook until it reduces in half, about 5 minutes. Add the reserved kombu water, fish bones, bonito flakes, anchovies, bay leaves, and parsley. Bring to a simmer, reduce the heat to low, and let simmer for 30 minutes. During that time, scoop any scum that forms at the top.
4. After the broth has finished its simmer time, carefully strain through a fine-mesh strainer into another container to separate the broth from the ingredients, discarding those.
5. The broth can be stored in an airtight container in the refrigerator for up to 5 days.

CLOUDY DREGS INN BOUILLABAISSE

I'd been warned to keep an eye out for pirates while staying in Wayrest, so I mostly kept to short walks along the coast and the safety of the Cloudy Dregs Inn. There I was treated to some of the best seafood I've ever had—flavored sumptuously with saffron, fennel, fruit, and more! I saw fisherfolk go in and out every day, bringing their fresh catch. The bartender would occasionally point out members of the Restless League pirate crew, but I believe she was joking. The Restless League aren't still around, as far as I'm aware . . .

Level: ▢▊▊▊▢
Prep Time: 30 minutes
Cook Time: 40 minutes
Yield: 4 servings
Dietary Notes: Dairy-free
Cuisine: Redguard

◆

BROTH

2 tablespoons olive oil

3 shallots, minced

1 leek, white and green parts only, minced

1 fennel bulb, minced

4 Roma tomatoes, finely chopped

3 garlic cloves, minced

Kosher salt

½ teaspoon saffron

½ teaspoon paprika

1 thyme sprig

1 rosemary sprig

3 orange peels

½ cup dry white wine

4 cups Artaeum Takeaway Broth (page 87)

2 bay leaves

Pepper

BOUILLABAISSE

Broth, from above

1 pound cod, cut into large chunks

10 littleneck clams

1 pound Dungeness crab clusters

10 shrimp, shelled and deveined

½ pound lobster claws

Note: Any seafood can be used, depending on what you may have caught while out in the ocean! Keep in mind that cook times will vary.

CRUSTY BREAD

3 tablespoons olive oil

2 garlic cloves

1 teaspoon ground cumin

1 baguette, cut into thick slices

To make the broth:

1. In a large pot, heat the olive oil over medium-high heat. Add the shallots, leek, and fennel and cook until softened, about 10 minutes. Mix in the tomatoes, garlic, a pinch of salt, saffron, paprika, thyme, rosemary, and orange peels.

2. Pour in the dry white wine and cook until it reduces by half. Add the broth and bay leaves. Reduce the heat to medium-low, cover, and let simmer for 20 minutes.

3. Remove the thyme sprig, rosemary sprig, and bay leaves and blend with an immersion blender until smooth. Season with salt and pepper.

To make the bouillabaisse:

1. Increase the heat on the broth to medium-high heat. Once heated, add the cod and cook for 2 minutes.

2. Add clams and cook for another 3 minutes. Add the crab, shrimp, and lobster and cook until the shellfish opens and all the fish is cooked, about 3 minutes.

To make the crusty bread:

1. In a small bowl, combine the olive oil and garlic cloves and let sit at room temperature for 30 minutes. Add the cumin and mix together.

2. Preheat the oven to 400°F. Place the baguette slices on a baking sheet. Brush one side of each slice with the seasoned olive oil.

3. Place in the oven and bake for 4 minutes. Flip, brush the other side of the bread, and bake for another 4 minutes. Serve warm with the bouillabaisse.

ELSWEYR HEARTY NOODLES

Tsaltima entertained me now and then by describing the varied foods she used to eat in Elsweyr. As she described the savory broth and light, filling noodles of this dish, she began to actually drool. We were in Cyrodiil at the time and had a hard time hunting down the ingredients to sate her cravings. Finally, we met a Khajiit named S'kavva in Bravil who could sell us the proper kind of duck. He chatted to us about his great-great-great-great grandmother, who used to smuggle expensive Elsweyrian luxuries into Cyrodiil via the Thieves Guild. His stories made me thankful to be alive in the contemporary era despite my love of history, for so many foods are more easily accessible now!

Level: ▞▌▌▌
Prep Time: 1 hour
Inactive Time: 24 hours
Cook Time: 1 hour
Yield: 4 servings
Dietary Notes: Dairy-free
Cuisine: Khajiit

ROAST DUCK LEGS

4 duck legs

Kosher salt

1 tablespoon Chinese five-spice powder

1 teaspoon ground coriander

1 orange zest

1 lemon zest

2 tablespoons olive oil

1 teaspoon dark brown sugar

SOUP

6 cups chicken broth

1 lemongrass

2-inch piece ginger, sliced

2-inch piece ginseng, sliced

2 star anise pods

2 teaspoons soy sauce

1 teaspoon Shaoxing wine

8 ounces yu choy, stemmed and leaves cut into large strips

12 ounces rice noodles, cooked

2 scallions, chopped

Note: Shaoxing wine can be substituted with another cooking wine (dry sherry is likely the best option), and bok choy can be used in place of yu choy. (You could also use spinach in a pinch.) Ginseng is stocked in most grocery stores, but if you can't find it, you can omit it from the recipe and it will still taste good.

To make the roast duck legs:

1. Place the duck legs, skin-side up, on a mesh strainer over a sink. Bring about 3 cups of water to a boil. Pour half of the water onto the duck. Flip the duck legs and pour the remaining water over them.
2. Transfer the duck to a wire rack on a baking sheet. Pat the duck completely dry. Generously season all parts of the duck with salt. Place in the refrigerator, uncovered, and let rest for 12 to 24 hours.
3. Preheat the oven to 325°F.
4. Remove the duck from the refrigerator and prick the skin with a toothpick. In a small bowl, combine the Chinese five-spice powder, coriander, orange and lemon zest, olive oil, and brown sugar.
5. Rub the seasoning all over the duck legs and place back on the wire rack, skin-side up. Place in the oven and bake for 45 minutes.
6. Increase the heat to 425°F and bake for another 15 minutes, or until the skin has crisped up. Remove from the oven, cover in aluminum foil, and let rest for 10 minutes.

To make the soup:

1. In a medium pot, combine the chicken broth, lemongrass, ginger, ginseng, and star anise. Heat over medium-high heat and bring to a boil. Reduce the heat and simmer for 20 minutes.
2. Remove the lemongrass, ginger, ginseng, and star anise from the broth. Add the soy sauce and Shaoxing wine and mix well. Add the yu choy and cook until wilted.

To assemble:

1. Place 3 ounces of rice noodles at the bottom of the bowl. Place one-quarter of the yu choy and scallions on top. Place one of the duck legs in the bowl. Pour one-quarter of the broth into the bowl and serve hot.

HUNT-WIFE'S BEEF RADISH STEW

When I was a child, I accompanied my father to Dushnikh Yal, a neighboring stronghold. It was a trip to keep relations—get in fights, scope out future husbands for my sister, and the like. In the evenings, we were served a stew that was so tender, so delectable, that in my travels I made sure to stop by Dushnikh Yal again. I learned this recipe from Arob, hunts-wife of the chief, who says it was passed down from the hunts-wives of old Betnikh.

Level:

Prep Time: 1 hour
Cook Time: 5 hours
Yield: 6 servings
Dietary Notes: Dairy-free
Cuisine: Orsimer
Equipment: 10-inch Dutch oven with lid

Canola oil, for frying

3 pounds beef short ribs

1 onion, large slices

2-inch piece ginger, chopped

5 garlic cloves, chopped

4 scallions, white parts only, chopped

2 tablespoons honey

2 tablespoons dark brown sugar

1 daikon, peeled, quartered, and sliced into ½-inch pieces

2 carrots, cut into 1-inch pieces

2 parsnips, cut into 1-inch pieces

½ cup soy sauce

1 cup Pack Leader's Bone Broth (page 99)

2 teaspoons fish sauce

½ cup mirin

1 star anise pod

½ cinnamon stick

ADDITIONALS

16 ounces glass noodles, cooked

2 scallions, chopped

1. Preheat the oven to 250°F. Heat a Dutch oven over medium-high heat and begin heating up 2 tablespoons of canola oil.

2. Add a single layer of short ribs to the Dutch oven, but do not overcrowd. Brown all sides of the meat. Remove and place on a plate. Add more canola oil and continue this process until all the beef has been browned.

3. Add more canola oil to the Dutch oven. Add the onion and cook until softened, about 5 minutes. Add the ginger, garlic, and scallions and cook for about 3 minutes. Add the honey and brown sugar and mix until well combined.

4. Add the daikon, carrots, and parsnips to the Dutch oven. Mix to cover with the oil and cook until the vegetables are slightly softened, 5 to 8 minutes.

5. Add the short ribs. In a small bowl, combine the soy sauce, broth, fish sauce, and mirin. Pour into the Dutch oven and mix until everything is slightly coated in the sauce. Add the star anise and cinnamon stick.

6. Cover and place in the oven. Cook for at least 4 hours, or until the beef is tender. Check and stir every 90 minutes. Remove and discard the star anise and cinnamon stick. Serve with glass noodles and scallions.

LAVA FOOT SOUP AND SALTRICE

Scrib jelly can be a difficult ingredient to utilize well. It can be rather unseemly, especially once you've seen the creature it comes from, but it is also quite miraculous. In Morrowind, the lumpy jelly is a common ingredient for curatives of the disease known as the Blight. And when prepared well, it becomes a delectable topper for all sorts of dishes!

Level: ◁▮▮▭▷
Prep Time: 45 minutes
Cook Time: 3½ hours
Yield: 6 servings
Dietary Notes: Dairy-free, gluten-free
Cuisine: Dunmer

SCRIB BROTH

6 cups chicken broth

1 pound chicken feet

2 leeks

2 tablespoons black peppercorns

2 bay leaves

Note: Scrib jelly can be very difficult to find for the average person. Chicken feet are just as gelatinous and a perfect replacement.

SOUP

1 tablespoon olive oil

1 onion, chopped

1 leek, white and light green parts only, chopped

2 garlic cloves

3 celery stalks, chopped

3 carrots, chopped

½ cup dry white wine

1 tablespoon dried thyme

5 cups scrib broth

¾ cup wild rice

1 pound sweet potatoes, peeled and chopped

14 ounces coconut milk

Kosher salt

Ground black pepper

To make the scrib broth:

1. In a medium pot, heat the chicken broth, chicken feet, leeks, peppercorns, and bay leaves over medium-high heat and bring to a boil. Reduce the heat and simmer for 2 hours.

2. After the broth has finished simmering, carefully strain through a fine-mesh strainer into another container to separate the broth from all the ingredients, discarding those. Once cooled, it can be stored in an airtight container in the refrigerator for up to 5 days or placed into the freezer for up to 4 months.

To make the soup:

1. In a large pot, heat the olive oil over medium-low heat. Add the onion and leek and sauté until they become translucent, about 5 minutes. Add the garlic, celery, and carrots. Cook for about 10 minutes, until the carrots have softened slightly.

2. Pour in the white wine and cook until it reduces in half, about 5 minutes. Add the thyme and scrib broth. Add the wild rice and cook for 10 minutes.

3. Add the sweet potatoes and cook for another 40 minutes, or until the rice is tender. Add the coconut milk and cook until warmed up. Season with salt and pepper.

MUTTON STEW

Tsaltima was in possession of this recipe when we met, though she wouldn't tell me where she'd picked it up. From experimenting with the recipe, I believe I've landed on what I'll call a Bosmeri take on a Baandari dish—and quite delicious at that. The recipe that Tsaltima had also had this curious line at the end, which Tsaltima recommends I note: *"Throw out when rotten. Eat cake instead."* I couldn't add that as official instruction, as I've never managed to let the stew go to waste!

Level:
Prep Time: 30 minutes
Cook Time: 1 hour 15 minutes
Yield: 4 to 6 servings
Dietary Notes: Dairy-free, gluten-free
Cuisine: Bosmer
Equipment: 10-inch Dutch oven with lid

- 2 tablespoons garam masala
- 2 tablespoons ground cumin
- 1½ tablespoons fenugreek leaves
- 1 tablespoon ground cardamom
- 1 tablespoon ground coriander
- 1 tablespoon ground fennel seeds
- 2 teaspoons kosher salt
- 4 pounds lamb shoulder, cut into 1-inch cubes
- 3 to 5 tablespoons duck fat
- 3 onions, sliced
- 1 whole garlic, minced
- ⅓ cup light brown sugar
- 2 tablespoons tomato paste
- 4 cups Pack Leader's Bone Broth (page 99)
- 2 bay leaves
- 2 sweet potatoes, peeled and cut into chunks

1. In a large bowl, combine the garam masala, cumin, fenugreek leaves, cardamom, coriander, fennel seeds, and salt. Toss the lamb in the seasoning until completely covered.
2. In a Dutch oven, heat 1 tablespoon duck fat over medium heat. Add a single layer of the lamb, but do not overcrowd the Dutch oven. Brown all sides of the meat, then remove and place on a plate. Add more duck fat, if needed, and continue this process until all the lamb has been browned.
3. Add another tablespoon of duck fat to the Dutch oven. Add the onions and cook until softened. Add the garlic, brown sugar, tomato paste, lamb, and any remaining spices from the bowl. Stir everything to combine.
4. Add enough broth to just barely cover everything and stir together well. Add the bay leaves. Bring to a boil and then reduce the heat to low. Partly cover and let simmer for 30 minutes. Add the sweet potatoes and cook for another hour, or until the lamb is tender. Before serving, remove and discard the bay leaves.

PACK LEADER'S BONE BROTH

Would you believe me if I told you I sipped on this hearty broth with men who claimed to be werewolves? While traveling from Rorikstead to Dragon Bridge, I was welcomed into a small camp. The folks there shared with me this lovely, thick, restorative soup as we exchanged stories. One particularly hairy man bragged to me about how they had "joined" a pack. I wasn't sure what to believe, but as the night grew old, I heard them howling at the moon. I made my leave quickly—I didn't want to be there when the broth ran out!

Level: 〈▯▯ ▯〉
Prep Time: 30 minutes
Cook Time: 24 hours
Yield: 2 to 3 quarts
Dietary Notes: Dairy-free, gluten-free
Cuisine: Werewolf

◆

4 pounds beef bones

2 leeks, halved

1 whole celery, halved

5 carrots, halved

3 onions, halved

1 whole garlic, halved

3 bay leaves

1 tablespoon apple cider vinegar

1 pound chicken feet

Salt

1. In a large pot, combine the beef bones, leeks, celery, carrots, onions, garlic, bay leaves, and apple cider vinegar. Top with enough water to just cover everything. Heat over low heat. Cook for 18 to 24 hours. Check on the broth a few times and skim any scum that forms at the top.

2. During the last 6 hours of cooking, add the chicken feet. After the broth has finished simmering, carefully strain through a cheesecloth-lined fine-mesh strainer into another container to separate the broth from all the ingredients, discarding those. Once cooled, the broth can be stored in an airtight container in the refrigerator for up to 7 days or in the freezer for up to 4 months.

3. To serve as a sipping broth, heat up the broth and strain through a coffee filter. Season with salt to your liking.

Note: If you're using the broth as a base for a soup, you can skip straining the broth through a coffee filter. This is done to remove any excess fat or small particles, making it a very smooth and clear broth.

SHORNHELM OXTAIL SOUP

The people of Shornhelm are a tough bunch, much like my family back home. I suppose living in the center of Rivenspire among the Kurallian Mountains must beat a certain hardiness into you. I'd been looking forward to trying Shornhelm's food, but as soon as I stepped foot into a restaurant, I was ushered out. The waiter told me that the chef still harbored resentment for when Orsimer had burned Shornhelm to the ground in the Second Era. Protests caught in my throat: Orsinium had been razed by Bretons first! But I knew that these words would fall on deaf ears. Instead I made this soup, which I had found in an old Breton recipe book, and returned to the restaurant. With some persuading from the waiter and from his nose, the old chef allowed me in.

Level: ◁▯▯▯▷
Prep Time: 30 minutes
Cook Time: 4 hours
Yield: 4 to 6 servings
Dietary Notes: Dairy-free
Cuisine: Breton
Equipment: 10-inch Dutch oven with lid

½ cup all-purpose flour

2 teaspoons ground black pepper

2 teaspoons dried thyme leaves

1 teaspoon kosher salt

2 pounds oxtails

2 tablespoons canola oil, plus more as needed

2 onions, sliced

1 red onion, sliced

4 garlic cloves, chopped

3 carrots, peeled and cut into 1-inch-thick medallions

3 parsnips, peeled and cut into 1-inch-thick medallions

3 cups red wine

3 tablespoons tomato paste

2 cups Pack Leader's Bone Broth (page 99)

2 bay leaves

1. Preheat the oven to 325°F.
2. In a medium bowl, combine the flour, pepper, thyme, and salt. Add the oxtails and toss until fully coated.
3. In a Dutch oven, heat 1 tablespoon canola oil over medium heat. Add a single layer of the oxtail, but do not overcrowd the Dutch oven. Brown all sides of the meat, then remove and place on a plate. Add more canola oil and continue this process until all the beef has been browned.
4. Add another tablespoon of canola oil to the Dutch oven. Add the onions. Cook until the onions are softened, about 15 minutes. Add the remaining flour mixture from the bowl and toss until the onions are coated.
5. Add the garlic and cook for another 2 minutes. Add the carrots and parsnips and cook for 5 minutes. Add the oxtail back to the Dutch oven and stir together. Mix in the red wine, tomato paste, and bone broth. Stir together until the tomato paste has incorporated with the rest of the liquid.
6. Add the bay leaves and cover with a lid. Place in the oven and cook for 3 hours, or until the beef is tender. Remove the bay leaves before serving.

SOLITUDE SALMON-MILLET SOUP

I cooked this soup an unsupportable amount of times under Balagog's stern instruction. I felt that I'd managed a decent soup after two tries, but he continued to demand I start over. When my twelfth try wasn't approved, I finally protested—my Salmon-Millet Soup tasted exactly as any other Nord chef's across Tamriel did. Balagog responded, "Now you understand the problem!"

I iterated further, cutting back on the tomato to let the dill and lemon take focus. By the end of that evening, Balagog wanted seconds and thirds of my soup! I named the final recipe after the city where I'd developed it as well as the solitude in which my teacher had let me flounder through my lesson.

Level: ⬛⬛◻◻◻

Prep Time: 30 minutes

Cook Time: 50 minutes

Yield: 6 servings

Dietary Notes: Gluten-free

Cuisine: Nord

1½ tablespoons canola oil

½ onion, chopped

Kosher salt

Ground black pepper

2 garlic cloves, minced

1 celery stalk, chopped

1 carrot, chopped

3 cups Artaeum Takeaway Broth (page 87)

½ pound Yukon gold potatoes, chopped into large pieces

⅓ cup millet

½ pounds salmon

½ cup milk

½ cup half-and-half

2 teaspoons fresh dill, chopped

Juice of ½ lemon

1. In a large pot, heat the canola oil over medium-low heat. Add the onion and sauté until it becomes translucent, about 5 minutes. Season with salt and pepper. Add the garlic, celery, and carrot. Cook for about 7 minutes, until the carrot has softened slightly.
2. Add the broth and potatoes. Bring to a simmer, reduce the heat, and cook for 10 minutes. Add millet and simmer for another 20 minutes.
3. Add the salmon and cook until just cooked through, 5 to 8 minutes.
4. Add the milk, half-and-half, dill, and lemon juice. Mix until well combined and heated through. Season with salt and pepper.

WEST WEALD CORN CHOWDER

This hearty chowder was born in, as the name says, the West Weald region of Cyrodiil. While traveling through the countryside, I learned that it is traditional to serve this soup to homecoming warriors, especially those who have been away for a long time. It's said to bring both the returner and the hometown good fortune. I think it would be nice to make this dish for someone special someday.

Level: ▮▮
Prep Time: 30 minutes
Cook Time: 40 minutes
Yield: 4 servings
Dietary Notes: Vegetarian
Cuisine: Imperial

◆

1½ tablespoons olive oil

1 onion, chopped

1 fennel bulb, chopped

3 garlic cloves, minced

4 cups vegetable broth

1 pound Yukon gold potatoes

4 cups corn

2 teaspoons kosher salt

1 teaspoon ground black pepper

⅓ cup heavy cream

1. In a medium pot, heat the olive oil over medium-high heat. Add the onion and fennel and cook until they have softened, 8 to 10 minutes. Add the garlic and cook for another 2 minutes.

2. Add the vegetable broth, potatoes, corn, salt, and pepper. Bring to a simmer. Reduce the heat to medium-low. Simmer, uncovered, until the potatoes have softened, about 25 minutes.

3. Transfer half of the mixture to a blender and blend until smooth. Return to the pot and add the heavy cream. Cook until heated through, about 5 minutes. Season with more salt and pepper to taste.

ENTRÉES

ENTRÉES

◆

With every entrée that he served, Balagog always had a big adventure to go with it. From the time he secreted the recipe for Silvered Kippertrout away from the College of Sapiarchs to the one time he smoked skooma and created his recipe for Sunlight Soufflé, he had a story for every dish. As I became a seasoned traveler and chef, I kept waiting for equivalent adventures to occur—before I remembered that being brave was a prerequisite to having brave tales! Being rather a coward, I hadn't accumulated any stories that showed me in a courageous light. This was the case until I had made my first full trip around Tamriel and returned to Skyrim.

It was at this point that I entertained the idea of descending to Blackreach.

I had always had a fascination with Blackreach that centered around my love of history. Travelers that returned from Blackreach—and there weren't many—spoke of its majesty, the giant glowing mushrooms, its ancient Dwemer architecture. I had always imagined what it might be like to walk the very same halls that the Dwemer had walked, to cook in the kitchens that the Dwemer had used! But I had never, ever dreamed that venturing to Blackreach would really be possible. The wonder of possibly investigating the Dwemer was always

doused with accounts of the Falmer and the Chaurus.

However, along my travels I had heard of an almost mythical ingredient: the crimson nirnroot. It was said to have incredible properties and taste like magic itself. And it only grew in Fal'Zhardum Din—in Blackreach.

I couldn't stop thinking of the crimson nirnroot. It never left my mind entirely; instead it just rested in the back of my thoughts. I'd gathered a good bit of information about the mystery of the Dwemer's disappearance. Could I—would I dare—try to re-create Dwemer cuisine and potentially cook a dish that would set both culinary scholars and historians ablaze? My cookbook would be lauded by all, and it'd certainly be a good story to tell. I knew it would be dangerous, but I'd developed a slightly thicker skin over my travels (and a slightly thicker ego, it appears). I could never let the dream die.

I hired a small but capable band out of Whiterun to travel with me down under the Tower of Mzark: Vendos, Milha, and Robhston, of the Companions. They ferried me through the dark tunnels, deeper and deeper into the earth. We gave a wide berth to any sign of the Chaurus. We saw the first glimpse of a glowing mushroom and then a full vista of the city—dark silhouettes of massive structures lit up by the neon glow of massive fungi. I'll never forget that moment or the silence that fell

over us as we took the sight in with awe. I felt like we were bonded in that unforgettable experience . . . which doubled my shame for what happened next.

As soon as we approached the city, we were surrounded by shadowy figures—Falmer, who were soon upon us like a plague. I cowered, ran, and hid behind some rocks while Vendos, Milha, and Robhston fought like the warriors my father once wished I was. Only when it fell quiet, when all the footsteps had died away, did the feeling return in my fingers and toes. I crept out to see the aftermath—but there was none. Underneath the lights of the city, I saw the Falmer carrying away three struggling figures.

What was I to do? I couldn't return aboveground without my companions; I'd condemn myself as a horrible person, not to mention I'd probably be dead before I took two steps. But I had no chance of rescuing them—all three were much better combatants than I and had been soundly defeated by the Falmer. Worst off, Milha had been carrying my pack of ingredients, so I would soon be in need of food and water! The only thing I had was a small bottle of Sleeping Tree Sap that I'd been using to aid my rest at night. I tried to calm down, take stock of my surroundings, and make a plan in spite of how little I had to go on.

And a plan did pop into my head. It wasn't a good one, but it was a plan nonetheless. But it hinged on me finding the near-legendary Crimson Nirnroot! I set about combing the area, being sure to stay out of sight of any more Falmer patrols. As time wore on, I became more and more stressed, but then I heard the sound of a chime. I followed the faint sound and found a red plant, tucked between rocks.

I held the plant up to a glowing mushroom to study it. It had to be the Crimson Nirnroot! The hour had grown late, and I dared not leave my party in the Falmers'

clutches for much longer. So, against all the advice of ages of chefs, I closed my eyes, took a deep breath, and began chewing a leaf of the mysterious vegetable.

I was struck with awful pain almost immediately. I doubled over, clutching my stomach. And then I saw it—or rather, didn't see it. My fingers—no, my whole body—was invisible! I stuffed the nirnroot into my pocket, heart thumping in my chest, and made to follow the Falmer's trail.

After creeping around the city for hours, I found the cell my friends were being kept in—and the Falmer that were standing guard. I watched for what felt like an age, making sure to keep taking the Crimson Nirnroot, but the guards never left their post. I realized I needed to act. I quietly made my way into their camp and found their foodstore. I emptied the remainder of my Sleeping Tree Sap onto some dried meat and, without drawing any attention to myself, brought it back near the guards.

Somehow, thank Malacath, the plan worked! The two guards dropped to sleep after finding and eating the meat. I lifted the keys to the cell, unbound my companions, and, with the help of the rest of the Crimson Nirnroot, we all made a quick escape out of Blackreach.

Thus, I had my first courageous story but no Dwemer dish to pair it with! Instead, I cooked up a storm for my adventuring party once we were out in the sunlight again—with Stonetooth Bash Chicken, Roast Branzino, and Garlic and Pepper Venison Steak! As I talked and laughed with my friends, I realized that I'd never needed a story full of daring adventure to enjoy my main course, for I had plenty of stories to share about the people I'd met, learned about, and cared for. It may be a personal preference, but whenever I see Vendos, Milha, and Robhston now, I much rather enjoy catching up on new things we've learned than recounting the terrifying hours I spent fearing for our lives in Blackreach.

ARTAEUM PICKLED FISH BOWL

While on the Summerset Isles, I did some early morning fishing and brought in a most surprising catch: a waterlogged journal with exactly one recipe I could make out. Intrigued, I quickly assembled and ate the Pickled Fish Bowl. There must be some sort of magic contained within this dish because, for the rest of the day, fish were practically leaping into my hands! I still make this whenever I need to secure seafood for a dish, for its magic has never failed me. Its success is enough to make me believe in myth!

Level: ◇▮▮◇
Prep Time: 1 hour
Inactive Time: 30 minutes
Cook Time: 20 minutes
Yield: 4 servings
Dietary Notes: Dairy-free
Cuisine: Altmer

PICKLED VEGETABLES

6 radishes, thinly sliced

1 cucumber, thinly sliced

3 carrots, thinly sliced

PER VEGETABLE

½ cup rice vinegar

½ cup water

1 tablespoon honey

3 tablespoons sugar

1 tablespoon kosher salt

1 teaspoon black peppercorns

QUINOA

1½ cups tricolor quinoa

3 cups vegetable broth

1 teaspoon salt

1 tablespoon black sesame seeds

3 scallions, chopped

2 tablespoons cilantro, chopped

3 tablespoons rice vinegar

1 tablespoon olive oil

TUNA

3 tablespoons soy sauce

2 tablespoons yuzu juice

1 tablespoon white miso

2 teaspoons sesame oil

2 teaspoons rice vinegar

1 teaspoon lime zest

1 pound sushi-grade tuna, cubed

ASSEMBLY

1 sheet nori

1 avocado, sliced

Note: Yuzu juice can be substituted with a Meyer lemon.

To make the pickled vegetables:

1. In a large airtight container, combine the rice vinegar, water, honey, brown sugar, and salt. Add the black peppercorns and radish. Cover and place in the refrigerator for at least 30 minutes.

2. Repeat this with the cucumbers and carrots. The pickled vegetables can be stored in the refrigerator for about 1 week.

To make the quinoa:

1. In a medium pot, heat the quinoa, vegetable broth, and salt over medium-high heat. Bring to a boil, then reduce the heat to medium-low. Cover and simmer for about 15 minutes, or until the liquid has evaporated. Keep covered and let rest for 5 minutes.

2. Transfer the quinoa to a nonmetal bowl and combine with the black sesame seeds, scallions, cilantro, rice vinegar, and olive oil.

To make the tuna:

1. In a medium airtight container, combine the soy sauce, yuzu juice, miso, sesame oil, rice vinegar, and lime zest. Whisk together until well combined. Add the tuna and stir to combine. Seal the container and place in the refrigerator. Let the tuna rest in the refrigerator for 30 minutes, up to 1 hour.

To assemble and serve:

1. Prepare four bowls with nori and divide the quinoa evenly among the bowls. Top each serving with tuna, avocado, and pickled vegetables.

ORCISH BRATWURST ON BUN

This recipe is very close to my heart, as it is the one that I cooked for Balagog that convinced him to mentor me. Though a brat on a bun is hardly a new invention, this iteration has my own personal tastes cooked into it: Bog–Iron Ale for unique flavor, leeks and fennel to add a nuanced lightness. Balagog described it as deceitfully simple with a complex flavor! I miss him terribly, but I will always cook this with a smile.

Level: ◁▭▭▭▭▷
Prep Time: 30 minutes
Cook Time: 1½ hours
Yield: 4 servings
Dietary Notes: Dairy-free
Cuisine: Orsimer
Equipment: 10-inch cast-iron pan

PURPLE CABBAGE

1 tablespoon olive oil

½ onion, thinly sliced

1 fennel bulb, thinly sliced

2 leeks, white part only, thinly sliced

Kosher salt

Ground black pepper

½ medium red cabbage, cored and thinly sliced

2 tablespoons apple cider vinegar

1 tablespoon dark brown sugar

1 tablespoon honey

2 teaspoons caraway seeds

½ cup water

BRATWURST

4 brats

1 tablespoon olive oil, plus more as needed

2 onions, thinly sliced

1 tablespoon dark brown sugar

1 tablespoon fennel seeds

12 ounces dark beer

ASSEMBLY

4 sausage buns

Ground mustard, for topping

To make the purple cabbage:

1. In a large, deep pot, heat the olive oil over medium-high heat. Add the onion, fennel, and leeks and cook until softened, about 8 minutes. Add a pinch of salt and pepper.
2. Add the cabbage, stir together, and cook for 5 minutes. Add the apple cider vinegar, brown sugar, honey, caraway seeds, and water. Bring to a light boil and then reduce the heat to medium-low. Cover and cook until the cabbage is tender, about 25 to 30 minutes. Season with additional salt and pepper. Cover and keep warm until the bratwurst are ready to serve.

To make the bratwurst:

1. As the cabbage simmers, in a cast-iron skillet, heat the olive oil over medium-high heat. Add the brats and cook until all sides are golden brown, about 5 minutes per side. Remove the brats and transfer to a plate. If the skillet is dry, add more olive oil. Add the onions and cook until softened and slightly golden, 15 to 20 minutes.
2. Add the brown sugar and fennel seeds. Mix until well combined with the onions. Add the beer and brats. Bring to a boil, then reduce the heat and simmer for 20 to 25 minutes, or until the brats are cooked through.

To assemble and serve:

1. Place the brat in a bun, then top each brat with mustard and cabbage.

PEACOCK CONFIT

A dish with a most extraordinary lineage: the Altmer keep meticulous accounts of their history, and this recipe shows up at many a ceremony or feast going back innumerable centuries. Its staying power is no wonder—the succulent meat, prepared slowly over time, simply melts in your mouth.

Level: ◁▯▮▮▯▷

Prep Time: 1 hour

Inactive Time: 12 hours

Cook Time: 3 hours and 15 minutes

Yield: 4 servings

Dietary Notes: Dairy-free, gluten-free

Cuisine: Altmer

Equipment: 10-inch Dutch oven with lid

⬦

⅓ cup kosher salt

2 bay leaves

1 tablespoon dried thyme

2 teaspoons dried rosemary

1 teaspoon dried sage

8 garlic cloves, finely minced

4 duck legs

2 to 5 cups duck fat

Ground black pepper

1. In a small bowl, combine the salt, bay leaves, thyme, rosemary, sage, and garlic. Mix together and lightly crumble the bay leaves. Rub on the duck legs and place in a single layer on a baking dish. Cover and place in the refrigerator overnight.

2. The next day, preheat the oven to 225°F. Rinse the salt mixture off the duck legs and pat dry.

3. Place the duck legs in a Dutch oven, but do not stack them. Melt the duck fat in a medium skillet and pour until it just covers the duck legs. Cover and bake until the duck is tender, about 3 hours.

4. Remove from the oven and let rest to room temperature. If not cooking that same day, place the duck in an airtight container and cover with duck fat. The duck can be stored in the refrigerator for up to 3 days.

5. To serve, heat a skillet over medium heat. Generously season the duck with pepper. Place the duck, skin-side down, and cook until the skin is crispy, about 6 minutes. Flip and cook until it is warmed through, another 3 to 5 minutes. Serve with your favorite green vegetable and potato side.

ROAST BRANZINO

While sailing between Wayrest and Satakalaam, our merchant vessel was halted by a corsair ship of dubious nature. The corsairs who came aboard were polite enough, but they wandered below and above deck, looking for what I presume was gold. Our ship was uneasy—we all stood around, tense, waiting for something bad to happen. One of the corsairs approached me in a rather shifty way. I felt the hairs on my neck stand and my pointed teeth ache. But as it turned out, she had just spotted me preparing fresh branzino.

 The first bite she took made her face wrinkle. She told me I was "cooking it wrong"— branzino was best stuffed with lemon, garlic, and parsley. She asked whether we had any of those ingredients on the ship. We did. I roasted fresh catch three times with a growing audience of pirates. Apparently, they hadn't had anything good to eat for a few days. On my fourth try, my corsair friend was satisfied. The pirates left our ship without much plundering, though we didn't have any more branzino until the next catch!

Level: ◁▮▮▯▷
Prep Time: 30 minutes
Cook Time: 30 minutes
Yield: 4 servings
Dietary Notes: Dairy-free, gluten-free
Cuisine: Redguard

- ¼ cup olive oil
- 2 tablespoons harissa
- 2 tablespoons za'atar
- 4 whole branzino, fins, scales, and guts removed
- 2 lemons, thinly sliced, plus more wedges for serving
- 4 garlic cloves, thinly sliced
- Small handful parsley, for stuffing
- Kosher salt
- Ground black pepper

1. Preheat the oven to 425°F.
2. In a small bowl, combine the olive oil, harissa, and za'atar. Brush the branzino all over with the harissa mixture. Stuff the cavity of each branzino with lemon slices, garlic, and parsley. Generously season with salt and pepper.
3. Place the prepared fish on a wire rack set in a baking sheet. Place in the oven and bake for 10 minutes. Carefully flip the fish and bake for another 15 minutes, or until the fish is cooked through. Turn on the broiler and allow the skin to crisp up, about 2 minutes. Serve with some lemon quarters.

GARLIC AND PEPPER VENISON STEAK

I mentioned the Green Pact before, but I had actually not heard of it until my stay in Kvatch. I had become quite familiar with the owner of the Eight Blessings and struck a deal with him that served me well: I had a discounted stay in exchange for cooking in the evenings. One evening, a polite young Bosmer named Celthil sent back this dish untouched—and the next night, and the next. Eventually, I recovered my damaged ego enough to ask why the venison wasn't to their liking. Celthil very kindly explained how the Bosmer had pledged to never eat any vegetation—they couldn't touch the bell peppers, onions, and scallions in this recipe! I was mortified at my own ignorance and immediately whipped them up a veggie-less version in apology. Thankfully, Celthil had nothing but good to say about it. I've included the original dish here, though, as I think those who haven't taken the Pact would quite enjoy the greens.

Level: ◁▮▮▭▷
Prep Time: 1 hour
Inactive Time: 12 hours
Cook Time: 20 minutes
Yield: 4 servings
Dietary Notes: Dairy-free
Cuisine: Bosmer

MARINADE

¼ cup soy sauce

1 teaspoon fish sauce

1 teaspoon Worcestershire sauce

2 tablespoons rice wine

1 tablespoon honey

1 teaspoon black pepper

2 pounds venison steak, sliced

SAUCE

¼ cup soy sauce

¼ cup mirin

¼ teaspoon red pepper flakes

2 tablespoons cornstarch

GARLIC AND PEPPER VENISON STEAK

10 garlic cloves, minced

2 tablespoons ginger, minced

4 scallions, white and light green parts only, minced

1 yellow bell pepper, sliced

1 orange bell pepper, sliced

2 onions, sliced

Peanut oil, for cooking

Cooked rice, for serving

1. In a small bowl, combine the soy sauce, fish sauce, Worcestershire sauce, rice wine, honey, and black pepper. Cover the venison with the mixture and place in the refrigerator in a large airtight container overnight. Remove from the refrigerator and let rest for an hour at room temperature.

2. In a small bowl, combine the soy sauce, mirin, red pepper flakes, and cornstarch for the sauce and set aside. Heat a wok over high heat. Add some peanut oil and sear half of the marinated venison until it has browned. Remove the venison, adding more oil if needed, and repeat with the remaining half of the steak.

3. Remove the steak and wipe down the wok. Add the garlic, ginger, and scallions and cook for 30 seconds to soften. Add half of the bell peppers and onions and cook until softened, about 8 to 10 minutes. Remove the vegetables, adding more oil if needed, and repeat with the remaining bell peppers and onions.

4. Once the last half of the bell peppers and onions have softened, return the steak and first half of the bell peppers and onions to the wok. Toss together and add the sauce. Cook until the sauce has slightly thickened. Serve in a bowl over cooked rice.

PHEASANT ROAST

This dish isn't particularly historic, but I felt the need to include it for two reasons: First, it's a popular staple, and for good reason. Pheasant Roast is always an acceptable main to serve as a host. Second, I was shocked and sorry to find that despite every restaurant in Whiterun listing Pheasant Roast as one of their recommendations, it was always overdone! It was thoroughly depressing to repeatedly eat dry pheasant. If you follow this recipe, you should be able to avoid such a morose fate.

Level:

Prep Time: 1 hour
Inactive Time: 18 hours
Cook Time: 50 minutes
Yield: 2 servings
Dietary Notes: Dairy-free
Cuisine: Nord

1 whole pheasant

Kosher salt

1 orange, quartered

1 tablespoon dried thyme

2 teaspoons dried sage

1 tablespoon dried rosemary

2 pounds Yukon gold potatoes, quartered

2 fennel bulbs, sliced

4 shallots, sliced

4 rainbow carrots, peeled and cut into 1-inch cubes

2 tablespoons olive oil

Nonstick cooking spray, for greasing the baking sheet

Ground black pepper

1. The night before you plan on cooking the pheasant, take it out of its packaging and remove and discard all the extra bits inside the cavity. Prepare a baking sheet with a paper towel layer. Place the pheasant on top of the paper towel. Generously season the pheasant with salt all over, inside and out. Put in the refrigerator, uncovered, for 18 hours (up to 24 hours).

2. Take the pheasant out of the refrigerator. Use the paper towel to clean up any liquid or blood that might have ended up on the pan while it rested. Place the orange in the cavity of the pheasant. Season the entire pheasant with the thyme, sage, and rosemary.

3. Preheat the oven to 400°F.

4. In a large bowl, combine the potatoes, fennel, shallots, carrots, and olive oil. Toss until all the vegetables are coated.

5. Line a baking sheet with aluminum foil and cooking spray. Transfer the vegetables to the baking sheet and season with salt and pepper.

6. Place the pheasant on top of the vegetables. Bake for 40 to 60 minutes, or until the internal temperature reads 165°F. Remove from the oven and cover with aluminum foil. Let it rest for 10 minutes before cutting to serve.

PORT HUNDING CHEESE FRIES

Tsaltima joined me as I visited Port Hunding—although to my dismay, she kept referring to it as "Port Funding" and insisting that she would introduce me to "some very rich friends." I attempted to steer clear of whatever she meant by signing us both up for a tour of Port Hunding's history: The city is named after a First Era Redguard hero named Frandar Hunding, who had a reputation for being invincible with a sword. The tour culminated in a market, where we were pushed into buying some of these deliciously cheesy fries. Allegedly, eating them makes you as invincible as Frandar Hunding! After the tour, Tsaltima succeeded in shepherding me into a building filled with sickly sweet smoke. She began to introduce me to one of her "friends" when another voice shouted from across the room. A string of obscenities bombarded my ears as Tsaltima pushed me back out onto the street. "Tsaltima may have forgotten on what terms she left here! Best to leave now, yes?" Perhaps the fries were more effective than I give them credit for, because we got away safely.

Level: ◁▮▮▮▯▷
Prep Time: 1 hour
Cook Time: 5 hours
Yield: 6 servings
Dietary Notes: N/A
Cuisine: Redguard
Equipment: 10-inch Dutch oven with lid

LAMB BROTH

2 lamb shanks

2 teaspoons kosher salt

1 teaspoon ground black pepper

3 tablespoons canola oil, divided

1 pound lamb ribs

1 carrot, roughly chopped

2 celery stalks, roughly chopped

1 red onion, roughly chopped

1 whole garlic, roughly chopped

4 cups Pack Leader's Bone Broth (page 99)

1 cup water

3 bay leaves

2 tablespoons cumin seeds

1 tablespoon coriander seeds

1 tablespoon whole black peppercorns

To make the lamb broth:

1. Generously season the lamb shanks and ribs with salt and pepper.
2. In a Dutch oven, heat 1 tablespoon canola oil over medium-high heat. Add the lamb shank and brown all sides, 3 to 5 minutes per side. Transfer onto a plate. Add another tablespoon of canola oil and the lamb ribs. Cook until browned on all sides, 2 to 3 minutes per side. Transfer to the same plate with the lamb shanks.
3. Add another tablespoon of canola oil, the carrot, celery, onion, and garlic and cook until slightly softened, about 8 minutes.
4. Add the broth, water, and lamb. Finally, add the bay leaves, cumin seeds, coriander seeds, and peppercorns. Cover and reduce the heat to low. Cook until the lamb is tender and easily comes apart, 3 to 4 hours.
5. Once the broth is ready, strain and set the broth aside. Shred the lamb, discarding the bones and fat. The lamb and broth can be stored separately in the refrigerator for up to 3 days.

Recipe continues on page 124.

Recipe continued from page 123.

POTATO WEDGES

¼ cup olive oil

1 tablespoon za'atar

1 teaspoon sumac

½ teaspoon ground black pepper

1 teaspoon kosher salt

3 russet potatoes, peeled and cut into wedges or thick fries

Nonstick cooking spray, for greasing the baking sheet

GRAVY (PER SERVING)

9 tablespoons unsalted butter

¾ cup all-purpose flour

3 cups lamb broth

Kosher salt

Ground black pepper

ASSEMBLY

⅓ cup cheese curds

Potato wedges, for topping

Shredded lamb, for topping

1 scallion, diced

3 fresh mint leaves, chopped

2 tablespoons labneh

Note: Local grocery stores often carry labneh, but if needed, Greek yogurt works as a substitute.

To make the potato wedges:

1. Preheat the oven to 450°F. In a large bowl, combine the olive oil, za'atar, sumac, pepper, and salt. Toss the potato wedges in the mixture.
2. Line a baking sheet with aluminum foil and grease with cooking spray. Transfer the seasoned potato wedges onto the sheet and place in the oven. Bake for 15 minutes. Toss and bake for another 15 minutes. Turn on the broiler and cook the wedges until they are crispy, 4 to 5 minutes.

To make the gravy:

1. To prepare the gravy, place a pot over medium-high heat. Melt the butter in the pot. Once melted, whisk in the flour. Slowly add the broth while whisking. It is very important that you do this slowly while constantly whisking. This will allow the gravy to become nice and thick. Bring to a boil and then reduce the heat. Simmer until the gravy has thickened. Season with salt and pepper.

To assemble and serve:

1. Place a large portion of wedges in a bowl. Top with the cheese curds, shredded lamb, scallions, mint, and labneh. Finally, add the gravy on top.

SENCHAL CURRY FISH AND RICE

I arrived in Senchal with Tsaltima during Mid Year. She had warned me not to go into the markets without her. "This one knows you well, Urzhag, and the city, it will eat you alive!" I had no desire to meet danger, but the lovely smells wafting from the stalls were too much to resist; against her advice, I headed into the markets the next morning. To hear Tsaltima tell it, she found me hours later with empty pockets and tears running down my face. I hadn't been mugged—I had spent my gold on three servings of this wonderful dish!

Level:
Prep Time: 30 minutes
Cook Time: 25 minutes
Yield: 4 servings
Dietary Notes: Dairy-free
Cuisine: Khajiit

TURMERIC CHILI PASTE

½ yellow bell pepper

1 lemongrass stalk, chopped

1 tablespoon coriander seeds

2 teaspoons cumin seeds

¼ cinnamon stick

1 teaspoon black peppercorns

1 tablespoon red pepper flakes

1-inch piece turmeric, peeled and
 sliced

2-inch piece ginger, peeled and
 sliced

5 garlic cloves

2 shallots, halved

1 tablespoon coconut sugar

3 tablespoons lime juice

1 tablespoon vegetable oil

To make the turmeric chile paste:

1. In a food processor, pulse the bell pepper, lemongrass, coriander seeds, cumin seeds, cinnamon, peppercorns, red pepper flakes, turmeric, ginger, garlic, shallots, coconut sugar, lime juice, and oil until extremely smooth. This paste can be stored in the refrigerator in an airtight container for up to 1 week.

Recipe continues on page 128.

Recipe continued from page 127.

SENCHAL CURRY

1 tablespoon canola oil

3 shallots, diced

1 king oyster mushroom, sliced

5 ounces broccolini, cut into 2-inch pieces

1 cup vegetable broth

2 cups coconut milk

Salt

Ground black pepper

1 pound cod, cut into large portions

1 tablespoon fish sauce

1 tablespoon lime zest

2 tablespoons lime juice

ADDITIONALS

2 cups rice, cooked

Cilantro, for topping

Scallions, minced, for topping

To make the senchal curry:

1. In a medium pot, heat the canola oil over medium-high heat. Add the shallots and oyster mushroom. Cook until the mushroom begins to soften, 5 to 8 minutes. Add the broccolini and cook for another 2 minutes.
2. Add the chile paste, vegetable broth, and coconut milk. Bring to a simmer and reduce the heat to medium.
3. Generously season all sides of the cod with salt and pepper. Add the cod to the pot and cover. Cook for 8 minutes, or until the cod reaches an internal temperature of 145°F.
4. Add the fish sauce, lime zest, and lime juice.

To assemble and serve:

1. Divide the rice evenly among four bowls. Add a portion of the curry sauce and top with a piece of cod, cilantro, and scallions.

STONETOOTH BASH CHICKEN

I mentioned before that I cooked Stonetooth Bash Chicken in exchange for Rajhin's Sugar Claws (page 37); this is that recipe. I cannot claim credit for this dish, as it spans as far back in Orsimer history as the Second Era. More recently, though, it is known to be the favorite dish of Urzoga gra-Batul, also called the Bloodfall Queen. Gra-Batul is recognized as a formidable force and leader in the Orsimer tribes—renowned enough for my mother to name me after her. It's funny, then, that I turned out to be such a woeful warrior! Were I ever to meet the Bloodfall Queen, I hope that my skill with this recipe would make up for my lack of combat ability.

Level: ◁▭▭▭▭▷
Prep Time: 1 hour
Inactive Time: 24 hours
Cook Time: 1 hour
Yield: 1 whole chicken
Dietary Notes: Dairy-free, gluten-free
Cuisine: Orsimer
Equipment: Charcoal grill, chimney starter, charcoal, applewood

5 pounds whole chicken

Kosher salt

Ground black pepper

¼ cup olive oil

2 tablespoons light brown sugar

1 tablespoon paprika

8 garlic cloves

3 rosemary sprigs, stemmed and chopped

1. Take the chicken and flip it so the back is facing up. Using a pair of kitchen shears, cut along both sides of the spine of the chicken and remove it.

Note: You can use the spine in a chicken broth.

2. Flip the chicken and spread the legs so they are lying flat. Press firmly on the breastbone until it cracks. The chicken should now be lying quite flat.

3. Line a baking sheet with a wire rack. Transfer the chicken onto the rack, keeping it flat, breast-side up. Generously season with salt and pepper. Put the chicken in the refrigerator, uncovered, for 18 to 24 hours.

4. The next day, in a food processor, pulse the olive oil, brown sugar, paprika, garlic, and rosemary until smooth. Remove the chicken from the refrigerator and brush every part of the bird with the mixture. Allow the bird to rest at room temperature for 30 minutes before placing it on the grill.

5. To prepare the grill, light charcoal briquettes in a chimney starter. Once the charcoal turns slightly white, toss it out of the charcoal chimney to one side of the grill. Top with three chunks of applewood. Let the wood burn until the smoke is no longer black.

6. Place the grill rack and lid on the grill. Make sure the vents on the lid and bottom of the grill are half open. Let the grill rack warm up.

7. Place the chicken on the side of the grill without the charcoal to let it cook over indirect heat. Place the lid on the grill, with the half-open vent on top of the chicken. Grill for 40 to 60 minutes, or until the internal temperature reaches 165°F. Remove from the grill and cover with aluminum foil. Let it rest for 10 minutes before cutting to serve.

SIDES

SIDES

◆

I visited the Summerset Isles a few times throughout my travels, but only once did I go to the College of Sapiarchs. I had come with two other chefs, requesting permission to research. So marvelous, to see its towers and spires on the glimmering ocean horizon as we approached! Unfortunately, I couldn't fully appreciate the view, as I was struck with a roiling stomach born half out of seasickness and half out of nerves. I'd never interacted with so many educated and impressive scholars. Although the Altmer had opened their doors to non-Altmer, I knew from prior visits to the isles that many of their people still had hesitations about outsiders. My desire not to disappoint made me dread interacting with Aldmeri scholars almost as much as the Falmer in Blackreach!

A welcoming party waited for us as we arrived: three Altmer. Two of them showed no prejudice—they couldn't have been warmer and more inviting. The third, though, remained impassive and cordial at best. He was introduced as Arinmir Larethiath, Assistant Sapiarch of Culinary Arts. No wonder he was

so reserved, so aloof! A mere beginner had no chance of measuring up to a Sapiarch's profound knowledge of cuisine. I was intimidated and avoided interacting with him as much as possible.

We weren't permitted to access the compound or the libraries, but they had prepared for us a small collection of historic recipes and culinary textbooks—I was flabbergasted by their generosity. As if that wasn't good enough, in the evening we were invited to a small banquet hosted by the Sapiarch of Culinary Arts! I was extremely anxious—my only piece of formal attire was a humble tunic I'd bought secondhand in Cyrodiil. I worried about my table manners and even more about seeming ignorant of what would be a purely Aldmeri dining experience. Arinmir and his colleagues would surely scorn me.

I fretted and worried through our arrival at the banquet. I barely tasted the appetizer, some gorgeous Aldmeri seafood, delicately decorated with an artistic swirl of tiny leaves. I could feel the eyes of the Sapiarchs on me, particularly those of Arinmir Larethiath,

who wore a scowl so disparaging that I missed the announcement of the entrée entirely. I was beginning to regret coming at all when the sides were brought out.

In my shock, I forgot to feel nervous! The sides were many, and unlike the aperitifs and the main dish, were from all over the world. Bravil's Best Beet Risotto from Cyrodiil, Argonian Swamp Shrimp Boil, rice cooked in the Alik'r fashion—even mini Orsimer-style venison pies! As the sides were presented, the chef to my left side momentarily evacuated her seat. An instant later, Arinmir Larethiath filled the seat, and I found myself in conversation with him.

"So, Gourmet's disciple, what do you think of this spread? Hardly enough variety, I'd say—you'd think they'd be able to serve at least two dishes from each region, being the College."

"Er, sorry?"

"For such refined palettes as ours? I haven't studied the flora and fauna across Tamriel to be served some weeds I could pick outside my doorstep. Gro-Larak, was it? You're from northwest Skyrim? I told the Sapiarch you'd appreciate foods from beyond your lands, but no one here listens to me. I'm just the Assistant."

As it turns out, even though the Isles may resist outsiders, certain Altmer are very hungry for outside influence at their dinner tables! And I've come to find that it's the same across Tamriel: People want variety and different perspectives. The same foods, drinks, people get boring without change—a lesson I took onward into the rest of my travels.

Ah, yes—I ended up exchanging contacts with Arinmir, who is quite sociable in spite of his reluctance to be pleased. He even volunteered himself as editor for this book!

APPLE MASHED POTATOES

I received a letter from Hasah and Irrielle, my friends from Turnpoint, telling me all about the goings-on of the village. This Nordic recipe was included in the letter. Irrielle told me it was their daughter's favorite and hoped I'd enjoy it too. Funnily enough, when I served this to Arinmir, he had nothing bad to say about the dish, which is a rare occasion. It's a favorite of children and elitists alike.

Level:
Prep Time: 30 minutes
Cook Time: 1 hour
Yield: 6 servings
Dietary Notes: Vegetarian
Cuisine: Breton

½ pounds Granny Smith apples, peeled and cut into 1-inch pieces

2 pounds russet potatoes, peeled and cut into 1-inch pieces

Kosher salt

¼ cup unsalted butter

8 ounces cream cheese

2 tablespoons honey

4 ounces Gorgonzola

Ground black pepper

1. Preheat the oven to 375°F.
2. Place the apple pieces on a parchment paper–lined baking sheet. Bake for 30 minutes, or until the apples have softened and are golden. Transfer to a cutting board, let cool, and finely chop the apples. Set aside.
3. Place the potatoes in a large pot with just enough water to cover them, add a pinch of salt, and bring to a boil over high heat. Reduce the heat and simmer for 15 to 20 minutes, or until the potatoes are tender.
4. Drain the potatoes. Place the pot back on the stove and add the butter, cream cheese, and honey. Add the potatoes and mash until smooth.
5. Add the Gorgonzola and apples and mix. Season with salt and pepper to taste.

ASHLANDER OCHRE MASH

While traveling the Grazelands, I made the rookie mistake of stepping near a kwama nest. My leg was swarmed by scrib—I couldn't tell you how long I lay paralyzed, but eventually a pair of Ashlanders found and revived me. To thank them, I gave them a pouch of moon sugar, which they studied carefully before accepting. I later learned that gift-giving is a staple of Ashlander culture and rather risky!

The pair introduced themselves as Zanthan and Ralymir of the Zainab. I had met Dunmer before but never nomads—I was eager to ask more about Ashlanders, for I hadn't heard much before. However, Ralymir told me that the tribes are cautious about sharing their history and stories and traditions with outsiders. According to Ralymir, outsiders—and even non-nomadic Dunmer—have taken their words and twisted them for purposes that hurt the Ashlanders. I was disappointed to miss insight into a different culture, but I understand the wish to keep their lifestyle their own. Zanthan did say that I could share the recipe for this delicious mash, though, so I can't complain!

Level:
Prep Time: 45 minutes
Cook Time: 1½ hours
Yield: 6 portions
Dietary Notes: Vegetarian
Cuisine: Dunmer
Equipment: Six 5-ounce ramekins

2 pounds sweet potatoes

2 tablespoons olive oil

½ teaspoon kosher salt

1 teaspoon ground black pepper

2 tablespoons dark brown sugar

2 teaspoons ground cinnamon

1 teaspoon ginger paste

½ teaspoon grated nutmeg

¼ teaspoon ground cloves

2 tablespoons honey

⅓ cup unsalted butter

2 sage sprigs

CRUMBLE

½ cup pecans, chopped

½ cup walnuts, chopped

½ cup dark brown sugar

1. Preheat the oven to 425°F.
2. Pierce each of the sweet potatoes several times with a fork. Rub each potato with olive oil, sprinkle with salt, wrap in aluminum foil, and then place on a baking sheet. Roast the sweet potatoes for 1 hour, or until tender.
3. Let the potatoes cool enough to be able to handle. Then remove and discard the skin, place in a medium bowl, and mash until smooth. Add the pepper, brown sugar, cinnamon, ginger paste, nutmeg, cloves, and honey. Mix until smooth and set aside.
4. In a small nonstick pan, heat the butter over medium heat. Once melted, add the sage and cook for 5 minutes. Remove from the heat, discard the sage, and pour the butter into the bowl. Mix until well combined. Split the mixture among the ramekins.
5. Preheat the oven to 350°F.
6. In a small bowl, combine pecans, walnuts, and brown sugar. Top each of the ramekins with the crumble. Place the ramekins on a baking sheet and bake for 25 minutes. Allow the ramekins to cool enough to touch and then serve.

BRAVIL'S BEST BEET RISOTTO

This recipe is said to have been made by an incredibly fortunate woman who lived in Bravil. I tried to find out who this woman was or what she might have done to earn her a lucky reputation. The only thing I could find was that a statue was erected in her honor within the city, but it seems to have been destroyed during the local skooma control crisis. I suppose her statue wasn't as lucky as she was!

Level: ◁▭▭▭▭▭▷
Prep Time: 45 minutes
Cook Time: 1½ hour
Yield: 4 servings
Dietary Notes: Gluten-free, vegetarian
Cuisine: Imperial

2 red beets, stemmed

6 cups chicken broth

3 tablespoons unsalted butter

1 onion, diced

3 garlic cloves, minced

2 thyme sprigs, leaves only

2 cups arborio rice

½ cup red wine

4 ounces goat cheese

3 ounces Parmesan cheese, shredded

Kosher salt

Ground black pepper

1. In a medium pot, heat the beets and chicken broth over medium-high heat and bring to a boil. Reduce the heat and simmer for 30 minutes. Remove the beets from the broth, transfer to a cutting board, and let cool. Keep the broth warm until it is used to make the risotto.

2. Once the beets have cooled, peel and discard the skin. Slice into bite-size pieces and set aside.

3. In a large pan, heat the butter over medium-high heat. Add the onion and garlic and cook until softened, about 5 minutes. Add the thyme leaves. Add the arborio rice and coat the rice with the butter. Sauté for 2 minutes, but do not let the rice brown.

4. Add the red wine and stir until all the liquid is absorbed. Slowly add the chicken broth in half-cup increments. Stir until the broth is fully absorbed before adding more liquid. Repeat until all of the broth is used and the rice is cooked through.

Note: This process can take a long time. Make sure to be patient and allow the rice to absorb the liquid with each addition.

5. Add the beets and mix together well, reserving a few pieces to place on top as garnish. Remove from the heat and stir in the goat cheese and Parmesan. Season with salt and pepper.

6. Divide the risotto among four bowls and arrange the reserved beet pieces in the center.

GILANE GARLICKY GREENS

This mouthwatering recipe comes with a story from the War of the Red Diamond: When Emperor Cephorus Septim defeated the Wolf Queen of Solitude, Hammerfell held many Skyrimian prisoners of war. Leafy greens had fallen out of fashion during the war, for farming vegetables took time and care that few had. Thus, the prisoners were deeply malnourished. One Redguard, a kitchen worker of Castle Gilane, cooked up kale, spinach, and chard and fed the sons and daughters of Skyrim, saving their lives so they could be traded back to their families.

Level: ▱▰▱
Prep Time: 15 minutes
Cook Time: 10 minutes
Yield: 4 servings
Dietary Notes: Gluten-free, vegan
Cuisine: Redguard

- 2 teaspoons za'atar
- 1 teaspoon ground black pepper
- ½ teaspoon kosher salt
- 2 tablespoons olive oil
- 1 whole garlic, minced
- 4 ounces kale, stemmed and cut into large chunks
- 4 ounces chard, stemmed and cut into large chunks
- 8 ounces spinach
- Zest and juice of 1 lemon

1. In a small bowl, combine the za'atar, pepper, and salt. In a large nonstick pan, heat the olive oil over medium-high heat. Add the garlic and cook until softened and lightly browned, about 3 minutes.

2. Add the kale, cover, and cook until it withers, about 2 minutes. Add the chard and spinach, cover, and cook until everything withers, 3 to 5 minutes. Add the za'atar mixture and lemon zest and juice. Mix until well combined and serve immediately.

HEARTHFIRE HARVEST PILAF

Early in the journey, I made my way across Skyrim, stopping at different towns to taste what they had to offer. One cold afternoon, I stopped at a local farm just outside Whiterun Hold and introduced myself to the residents.

The two who worked the farm were Holrich, a Nord born and raised in Whiterun, and Do'sha, a Khajiit who had arrived in a merchant caravan and never left. I could tell they didn't have much, but they took me in regardless. We drank warm tea by the fire and Holrich and I split our sides as Do'sha joked about their time in Skyrim. "This one thinks all the food here tastes the same! Just meat and potatoes, lucky to even have salt. No difference from a lump of clay, yes? You agree, Urzhag, yes? Terrible, terrible! It does not match Khajiit's tastes."

Holrich then brought up this dish, which he and Do'sha had created together—and we just had to stop and cook it right then and there. I was in rhapsodies about the subtle sweet flavor from the cinnamon and cranberry combination, though Do'sha still insists it tastes better with sugar mixed in!

Level: ⬜▮▮⬜
Prep Time: 30 minutes
Inactive Time: 5 minutes
Cook Time: 45 minutes
Yield: 6 servings
Dietary Notes: Dairy-free, gluten-free
Cuisine: Nord / Khajiit

1 pinch saffron threads

¼ cup boiling water

2 tablespoons unsalted butter

½ onion, minced

3 garlic cloves, minced

2 teaspoons kosher salt

⅓ cup dried cranberries

2 cardamom pods

1 cinnamon stick

3¾ cups chicken broth

1¼ cups basmati rice

¼ cup wild rice

⅓ cup pistachio, roughly chopped

1 tablespoon olive oil

8 ounces butternut squash, roughly chopped

1. Place the saffron and boiling water in a cup and let steep for 5 minutes. In a saucepan, melt the butter over medium heat. Add the onions and cook until translucent. Add the garlic and cook for 2 minutes, until fragrant.

2. Add the saffron water, salt, cranberries, cardamom pods, cinnamon stick, and chicken broth. Bring to a boil and then reduce the heat to low. Add the rice, cover, and cook until the rice has cooked, about 20 minutes. Set aside.

3. Heat a large nonstick pan over medium-high heat. Add the pistachios and toast slightly, cooking until they just start to brown (3 to 5 minutes). Once toasted, remove from the pan and set aside. In the same pan, heat the olive oil. Add the butternut squash and cook until it softens (8 to 10 minutes).

4. Add the cooked rice, mix well, and cook for about 5 minutes. Mix in the pistachios and transfer to a large serving bowl.

DESSERTS

FARGRAVE SWEETROLLS

In the Imperial City, I found myself learning from an eccentric Breton woman named Nanasien Gevlla, though she insisted I call her "Nana." Most of Nana's neighbors considered her either senile or dangerous, but for some reason I took to her immediately. She was a real night owl—I would head to her kitchen late into the evening and arrive to find her eating breakfast. After cooking with her, I started to understand her neighbors' perspectives a bit. Some of her dishes could've been better described as alchemy, and late one night there were one or two slight . . . explosions. But the oddest dish of Nana's was unexpectedly this twist on the classic sweetroll, which she claimed was "an old family recipe."

Her mother, she told me, had spent time on the plane of Fargrave in Oblivion, where she'd fallen in love with a Daedra! She spent many years in Fargrave before finally returning. Nana claimed she had grown up in Fargrave, and told me stories of baking these sweetrolls under ethereal skies.

I wasn't sure what to believe, but when I returned to the city a year later, her neighbors said she had disappeared. I like to think she made it back home.

Level: ◁▭▭▭▭▷
Prep Time: 1 hour
Inactive Time: 20 to 26 hours
Cook Time: 25 minutes
Yield: 8 sweetrolls
Dietary Notes: Vegetarian
Cuisine: Daedric
Equipment: Stand mixer with dough hook attachment (highly recommended), eight 3½-inch round tube cake tins

SWEETROLLS

2¾ cups bread flour, plus more for dusting

¼ cup sugar

1 tablespoon active dry yeast

1 teaspoon kosher salt

2 teaspoons ground cinnamon

1 teaspoon ground cardamom

1 teaspoon ground nutmeg

½ teaspoon ground ginger

¼ teaspoon ground allspice

3 eggs, room temperature

1 egg yolk, room temperature

¼ cup milk, room temperature

12 tablespoons unsalted butter, room temperature, plus more for greasing

Nonstick cooking spray, for greasing

To make the sweetrolls:

1. In a bowl of a stand mixer, combine the bread flour, sugar, yeast, salt, cinnamon, cardamom, nutmeg, ginger, and allspice. In a small bowl, whisk the eggs, egg yolk, and milk. Add the egg mixture to the stand mixer bowl and turn on to low, mix until everything just comes together, 5 to 8 minutes.

2. Add 1 tablespoon of butter to the bowl. Mix until it is well incorporated, about 2 to 3 minutes. Continue adding the butter this way until all of it has been added.

Note: It is extremely important to do this very slowly. If you add the butter too quickly, the dough will never come together.

3. Increase the speed to medium and knead the dough until it comes together into a ball, about 10 minutes. The dough is worked enough if it doesn't rip when you tug it slightly. Transfer to a lightly floured work surface and shape into a rough ball.

4. Grease a bowl with cooking spray and place the dough in it. Cover and let the dough rise at room temperature for 90 minutes, or until doubled in size. Transfer to the refrigerator and let rise for 18 to 24 hours.

Recipe continues on page 152.

Recipe continued from page 151.

FROSTING

2 cups powdered sugar

½ teaspoon kosher salt

1 teaspoon vanilla extract

½ cup plus 1 tablespoon heavy cream

⅛ teaspoon edible glitter

5 drops light blue food coloring

5. The next day, prepare the tube cake tins by rubbing the interior with butter. Transfer the dough to a lightly floured work surface. Punch down and knead slightly. Split into eight equal portions and shape into balls.

6. Take one of the buns and press a finger in the center to form a ring. Place in one of the prepared tins. Lightly press down so the dough is at the bottom of the tin. Repeat this process with the remaining portions.

7. Place the tins on the baking sheet and cover with a kitchen towel. Let rise for 2 hours or until the dough doubles in size.

8. Preheat the oven to 350°F.

9. Remove the kitchen towel and transfer the baking sheet with the tins into the oven. Bake for 20 to 25 minutes, or until golden brown and cooked through.

10. Remove the rolls from the tin and cool on a cooling rack.

To make the frosting and finish:

1. In a small bowl, whisk the powdered sugar, salt, vanilla, heavy cream, edible glitter, and food coloring until it is smooth and comes together. When the sweetrolls have cooled completely, dip the top of each of the sweetrolls in the frosting and serve immediately.

Note: I highly recommend frosting these sweetrolls when you are going to enjoy them. This allows you to store them in an airtight container at room temperature for up to 3 days.

COLOVIAN WAR TORTE

In not-so-distant history, Imperial forces often took these robust yet lavish desserts on war marches to facilitate camaraderie among their forces. I first learned the recipe in the Colovian Highlands, but I didn't understand its true value until one snowy evening in Western Skyrim. I'd had a full day of walking and the snow was starting to pick up—I'd spent enough winters in Skyrim to know what was coming. I ducked into a small cave for shelter, only to find two other travelers already there. We were each cold, tired, and rather suspicious of each other, until I whipped up a torte to share. The combination of nutmeg and citrus must have a touch of magic, for we spent the night joking and laughing like we'd known each other for years.

Level: ⬜▨▨▨
Prep Time: 1 hour
Inactive Time: 2 hours
Cook Time: 40 minutes
Yield: 1 cake
Dietary Notes: Vegetarian
Cuisine: Imperial

CAKE

Nonstick cooking spray, for greasing

2 cups all-purpose flour

2 teaspoons baking powder

1 teaspoon baking soda

2 teaspoons ground cinnamon

1 teaspoon ground ginger

½ teaspoon nutmeg

½ teaspoon kosher salt

10 ounces carrots, finely shredded

Zest of 2 oranges

¼ cup orange juice

1 cup vegetable oil

4 eggs

1 cup granulated sugar

½ cup dark brown sugar

To make the cake:

1. Preheat the oven to 350°F. Grease two 8-inch cake pans with cooking spray. Carefully line each pan with parchment paper.

2. In a medium bowl, combine the flour, baking powder, baking soda, cinnamon, ginger, nutmeg, and salt and set aside. In a large bowl, combine the carrots, orange zest and juice, vegetable oil, eggs, granulated sugar, and brown sugar. Mix together until well combined.

3. Add dry ingredients and mix until just combined. Be careful not to overwork the batter.

4. Split the batter evenly between the two prepared cake pans. Bang each pan lightly on the counter to remove any large air bubbles. Place in the oven and bake for 35 to 40 minutes or until a toothpick inserted into the middle comes out clean.

5. Let rest for 5 minutes and then remove from the pan onto a cooling rack. Make sure to remove the parchment paper from the cakes and allow them to cool fully (at least an hour of resting time).

Recipe continues on page 156.

Recipe continued from page 155.

CREAM CHEESE FROSTING

16 ounces cream cheese

8 tablespoons unsalted butter

2 teaspoons orange liqueur

Zest of 1 orange

4 cups powdered sugar

To make the cream cheese frosting:

1. In a large bowl, mix together the cream cheese and butter. Add the orange liqueur and zest. Once well mixed, begin to slowly add the powdered sugar ½ cup at a time. Whisk until the cream cheese frosting has thickened and is smooth. Transfer one-third of the frosting to a pastry bag with a frosting tip of your choice.

To assemble and decorate the cake:

1. Once the cake layers have fully cooled, level both layers by cutting the top bump with a serrated knife. Place one of the layers on your serving plate, cut-side up.
2. Add about ⅓ inch of frosting on top and spread evenly. Top with the other layer of cake, cut-side down.
3. Use the remaining frosting to cover the cake. Use the frosting in the pastry bag to add little details to the top and base of the cake. Let the cake sit covered in the refrigerator for at least 1 hour before cutting into it. It can be stored in the refrigerator, covered, for up to 4 days.

SANGUINE "SHAVEN FRUIT"

As I was traveling near Kynesgrove, I made camp with a humble group of mercenaries. They were a gruff and altogether reserved group, but they welcomed me around their fire for the night. After a few hours spent in comfortable silence, another traveler arrived, a young man who introduced himself as Sam. He asked if he could share the fire and would gladly offer what provisions he had in return. When he laid out the contents of his pack, the battle-hardened mercenaries quickly offered him their hospitality, for his pack was filled with wines and ales!

As the night grew late, Sam produced more and more bottles of liquor—I don't know where he was keeping them. At the time, I wasn't too comfortable with alcohol, but I did find something to my liking in Sam's pack: the last few slices of this sweet peach treat, which I nibbled on as the camp swung back and forth between singing and fighting. I snuck off not much later as I heard the men shouting about hitting a local bar for more drinks! The recipe here is the closest I've managed to re-create the dessert I had that night, though it's never tasted quite as sweet . . .

Level: ◁▭▮▮▯▷
Prep Time: 1 hour
Inactive Time: 1 hour
Cook Time: 40 minutes
Yield: 8 servings
Dietary Notes: Vegetarian
Cuisine: Daedric
Equipment: Food processor

DOUGH

1½ cups all-purpose flour

1 tablespoon sugar

½ teaspoon ground cardamom

½ teaspoon nutmeg

Pinch kosher salt

½ cup unsalted butter, cubed and chilled

1 tablespoon amaretto

4 to 5 tablespoons ice water

To make the dough:

1. In a food processor, combine the flour, sugar, cardamom, nutmeg, and salt. Add the cubed butter. Pulse until the mixture resembles coarse meal with a few chunks of butter.
2. Add the amaretto and 3 tablespoons of water. Pulse until the dough comes together. Add another tablespoon of water. Pulse again until combined. If the dough is too dry, add the remaining water.
3. Remove the dough from the food processor and lightly knead to bring it all together. Wrap in plastic wrap and place in the refrigerator for at least an hour.

Recipe continues on page 160.

Recipe continued from page 159.

FILLING

1 pound peaches, thinly sliced

⅓ cup granulated sugar

2 tablespoons dark brown sugar

1 teaspoon ginger, grated

1 teaspoon lemon zest

2 teaspoons lemon juice

EGG WASH

1 egg, whisked

1 tablespoon coarse sugar

To make the filling:

1. In a large bowl, combine the peaches, granulated sugar, brown sugar, ginger, and lemon zest and juice. Toss to coat the peaches completely. Transfer to a strainer and place a bowl underneath. Let sit for at least 30 minutes.

Note: This step is done to remove any excess liquid from the fruit. You do not want to add too much liquid to this tart or the bottom will be too soggy.

To assemble and bake:

1. Preheat the oven to 425°F.
2. Take the dough out of the refrigerator, unwrap it, and place it on a large sheet of parchment paper. Roll the dough out into a 12-inch circle. Transfer the parchment paper to a large baking sheet.
3. Arrange the peaches in the center, leaving a 2-inch border. Fold the edges toward the center, making a crust over the filling and leaving the center open. Fold the crust over itself as necessary as you work your way around the border.
4. Brush the crust with the egg and sprinkle with coarse sugar. Place in the oven and bake for 35 to 40 minutes, or until the crust is golden brown.
5. Remove from the oven and let cool for at least 45 minutes before cutting.

BANANA SURPRISE

Like Minstrel Banana Bread, this sugary dessert travels with Khajiit caravans. I've heard that the bananas the caravans take on the road are frozen to preserve them—with ice and snow when in cold regions, but with magic in hot regions! The technique seems to have been perfected by mages from the Rimmen Mages Guild in the Second Era—I tried to re-create it myself, but failed in a spectacular and chilling way. I'd better stick to ice and snow . . .

Level: ◁▯▯▯▯▷
Prep Time: 45 minutes
Inactive Time: 3 hours
Cook Time: 20 minutes
Yield: 4 servings
Dietary Notes: Vegetarian
Cuisine: Khajiit

PUDDING

2½ cups milk

½ cup sugar

1 teaspoon kosher salt

½ cup dulce de leche

5 tablespoons cornstarch

5 egg yolks

2 teaspoons vanilla extract

2 tablespoons unsalted butter

3 bananas, sliced

WHIPPED CREAM

2 cups heavy cream, cold

2 tablespoons amaretto

¼ cup powdered sugar

To make the pudding:

1. In a medium saucepan, heat the milk, sugar, and salt over medium-high heat until right before it starts to boil. Reduce the heat to low.
2. In a small bowl, combine the dulce de leche, cornstarch, and egg yolks until smooth. Mix until everything is well combined. Scoop out ½ cup of the heated milk mixture and slowly transfer to the bowl with the egg yolks while whisking. Repeat this twice.
3. Slowly add the mixture back into the saucepan. Increase the heat to medium-low and whisk everything together until it thickens.

Note: This step should take about 10 minutes. You'll get a workout, but it'll eventually come together.

4. Once the base has thickened, remove it from the heat. Add the vanilla and butter. Transfer the pudding to a medium bowl and allow it to cool to room temperature.
5. Prepare four bowls by placing half the sliced bananas at the bottom. Top each bowl with a few scoops of pudding. Create another layer with the remaining banana slices, then top with the remaining pudding. Cover and let it chill in the refrigerator for 4 hours before serving.

To make the whipped cream:

1. In a bowl of a stand mixer, combine the heavy cream, amaretto, and sugar. Whip on high speed until it reaches stiff peaks. If you aren't ready to serve, cover the frosting bowl with plastic wrap and place it in the refrigerator.
2. Serve the pudding with a hefty spoonful of whipped cream.

JUBILEE CAKE

Just this past year, I found myself in Daggerfall during Rain's Hand and happened upon a delightful jubilee! A famous cake chef was apparently in the area, preparing a fantastic cake. I searched high and low, hoping to meet him, but I never managed to encounter him. A shame, because the cake that was finally presented to the crowd was absolutely perfect! After tasting it, I returned to the Rusty Djinn and immediately began trying to re-create it. I believe the resulting recipe is the perfect pastry for celebrating any special occasion or anniversary.

Level: ⬦▭▭▭▭▭⬦
Prep Time: 1½ hours
Inactive Time: 12 hours
Cook Time: 1 hour
Yield: 1 cake
Dietary Notes: Vegetarian
Cuisine: Breton

BERRY FILLING

1 tablespoon lemon juice

3 tablespoons sugar

4 ounces cherries

4 ounces raspberries

4 ounces blueberries

4 ounces blackberries

1 tablespoon cornstarch

1 tablespoon water

CAKE

Nonstick cooking spray, for greasing

3 cups cake flour

1 teaspoon cardamom

1 tablespoon baking powder

1 teaspoon kosher salt

1 cup unsalted butter, room temperature

1½ cups sugar

1 tablespoon lemon zest

2 whole eggs

2 egg whites

1 teaspoon vanilla extract

1 Tahitian vanilla bean, seeds scraped and pod discarded

1¼ cup half-and-half

To make the berry filling:

1. The night before, in a medium saucepan, combine lemon juice and sugar. Bring to a boil. Add the cherries, raspberries, blueberries, and blackberries. Reduce to a simmer and cook for 10 minutes.
2. In a small bowl, whisk together the cornstarch and water. Add to the saucepan and cook until the mixture combines and thickens.
3. Transfer to an airtight container and let cool. Let sit in the refrigerator at least overnight, up to 1 week.

To make the cake:

1. Preheat the oven to 350°F. Prepare the cake pans by greasing the inside with cooking spray. Carefully line each with parchment paper.
2. In a medium bowl, whisk together the cake flour, cardamom, baking powder, and salt and set aside. In a large bowl, combine the butter, sugar, and lemon zest and mix until smooth. Add the whole eggs, egg whites, vanilla extract, and vanilla bean seeds.
3. Add half of the dry ingredients into the large bowl and mix well. Add the half-and-half. Mix until smooth. Add the remaining dry ingredients and mix until just combined.
4. Split the batter evenly between the two prepared cake pans. Bang each pan lightly on the counter to remove any large air bubbles. Place in the oven and bake for 40 to 45 minutes or until a toothpick inserted into the middle comes out clean.
5. Let the cakes rest for 5 minutes. Remove from the pan and place onto a cooling rack. Make sure to remove the parchment paper from the cakes and let them cool fully (at least 1 hour of resting time).

Recipe continues on page 166.

Recipe continued from page 165.

WHIPPED CREAM

3 cups heavy cream

1 teaspoon vanilla extract

1 cup powdered sugar

ASSEMBLY

¼ cup fresh blueberries

3 fresh strawberries, quartered

Note: Tahitian vanilla beans tend to have a fruity flavor, which makes them ideal for this recipe, but a regular vanilla bean will work if necessary!

To make the whipped cream:

1. In the bowl of a stand mixer, combine the heavy cream, vanilla, and powdered sugar. Whip on high speed until it reaches medium peaks. If you aren't ready to assemble the cake, cover the frosting bowl with plastic wrap and place it in the refrigerator.

To assemble:

1. Once the cake layers have fully cooled, level both layers by cutting the top bump with a serrated knife. Place one of the layers, cut-side up, on your serving plate.
2. Add about one-third of the frosting on top and spread evenly. Add the berry filling in a single layer. Cover with just enough frosting to cover the filling.

Note: Try to keep the berry filling in the center. If you go too close to the edge, it will leak!

3. Take the other cake layer and place, cut-side down, on top of the frosting. Top the cake with the remaining frosting, blueberries, and strawberries.
4. Let the cake sit covered in the refrigerator for at least 1 hour before cutting into it. It can be stored in the refrigerator, covered, for up to 3 days.

MARSHMERROW COOKIES

In Markarth, I came across a somewhat glamorous confectionery in the lower streets. Its lavishly decorated cookies and cakes clashed terribly with the ancient Dwemer surroundings. I popped inside and met the pâtissier, a young Dunmer woman who had just finished setting up shop. She hailed from Vvardenfell and was displaying a cake that looked like the Red Mountain as it exploded. I opted not for the cake but for these beautiful cookies, and she agreed to share the recipe if I would share her story in my cookbook. (Talili, I hope this is good enough marketing for you!)

Level: ◁▮▮▮▭▭▷
Prep Time: 45 minutes
Inactive Time: 24 hours
Cook Time: 20 minutes
Yield: 24 cookies
Dietary Notes: Vegetarian
Cuisine: Dunmer
Equipment: Blender

MARSHMERROW EXTRACT

15 pandan leaves

¾ cup water

COOKIES

1 cup macadamia nuts

2½ cups all-purpose flour

2 teaspoons baking powder

½ teaspoon kosher salt

1 cup unsalted butter, room temperature

¾ cup sugar

2 eggs

1 tablespoon Marshmerrow Extract

1 cup white chocolate chips

Note: If you would prefer to buy pandan extract rather than make it, it can be found at Asian grocers.

To make the marshmerrow extract:

1. In a blender, blend the pandan leaves and water until completely smooth. Line a mesh strainer with a cheesecloth. Pour the blended mixture through the cheesecloth into an airtight container.
2. Wrap the bits with the cheesecloth and squeeze to release any additional liquid. Cover and place in the refrigerator and let rest overnight.
3. The next day, the mixture should have separated, with a dark part on the bottom and a lighter green part on top. Carefully separate the two.
4. Discard the lighter part. The darker part is the marshmerrow extract. Cover and place back in the refrigerator for up to 3 days. This will make about ¼ cup extract.

To make the cookies:

1. Preheat the oven to 325°F.
2. Place macadamia nuts on a baking sheet and bake for 15 minutes, or until golden brown. Set aside to cool.
3. In a medium bowl, combine the flour, baking powder, and salt.
4. In a large bowl, beat the butter until smooth. Add the sugar to the butter and mix until smooth. Add the eggs and marshmerrow extract and mix until combined.
5. Slowly mix in the flour mixture until it just comes together. Add the macadamia nuts and white chocolate chips and fold until mixed well.
6. Scoop spoonfuls of the dough, about 2 tablespoons at a time, onto a baking sheet lined with parchment paper and press down slightly into a cookie shape. Repeat until all the dough has been prepared. Place in the refrigerator for 1 hour.
7. Preheat the oven to 350°F. Bake the cookies for 16 to 19 minutes, or until the edges are slightly golden. Let cool completely before serving.

PUMPKIN CHEESECAKE

I saw accounts of this creamy dessert pop up in the Third Era, but looking further back in history granted me the stronger original recipe! The earliest record I could find was in late First Era Cyrodiil, when Reman II had successfully pushed across most of Tamriel. Some Imperial scrolls brag that many nations joined willingly after tasting this Pumpkin Cheesecake. The Reman Dynasty had excellent propaganda so it's highly likely this boast is untrue, but every time I bite into this dish, I can't help but believe it a little!

Level: ◁▮▮▮▯▷
Prep Time: 45 minutes
Inactive Time: 8 hours
Cook Time: 1 hour 40 minutes
Yield: 1 cheesecake
Dietary Notes: Vegetarian
Cuisine: Imperial

CRUST

1½ cups ground gingersnap crumbs

1 teaspoon ground cinnamon

¼ cup dark brown sugar

¼ cup unsalted butter, melted

FILLING

24 ounces cream cheese

1 teaspoon kosher salt

1 teaspoon ground cinnamon

1 teaspoon ground cardamom

½ teaspoon nutmeg

½ teaspoon ground ginger

¼ teaspoon ground allspice

⅛ teaspoon ground cloves

2 tablespoons cornstarch

½ cup granulated sugar

½ cup light brown sugar

3 eggs

2 teaspoons vanilla paste

15 ounces pumpkin purée

14 ounces sweetened condensed milk

To make the crust:

1. Preheat the oven to 350°F.
2. In a small bowl, mix together the gingersnap crumbs, cinnamon, brown sugar, and melted butter until it all comes together.
3. Wrap the outside of a springform pan with two layers of aluminum foil. This is to help prevent too much direct heat, which tends to cause cheesecake to crack. Press down the graham cracker crumbs into the bottom of the pan to create a crust, until you have a nice flat layer at the bottom. Bake the crust for 10 minutes. Once the crust has baked, remove it from the oven and reduce the heat to 325°F.

To make the pumpkin cheesecake:

1. In a bowl of a stand mixer, whip the cream cheese until smooth.

Note: You will need to scrape down the sides a few times to make sure all the cream cheese is smooth.

2. Add the salt, cinnamon, cardamom, nutmeg, ginger, allspice, cloves, cornstarch, granulated sugar, and brown sugar. Mix well. Add the eggs, one at a time.
3. Add the vanilla paste. Mix well and scrape the sides to incorporate everything. Finally, add the pumpkin purée and sweetened condensed milk. Mix until well combined.
4. Place the springform pan in a large, deep baking tray. Pour hot water in the baking tray until about halfway up on the pan. This is done to avoid harshly cooking the cake and to prevent major cracks from forming on the top.
5. Pour the filling over the crust in the springform pan. Use a spatula to smooth out the top. Place in the oven and bake for 80 to 90 minutes, or until the cheesecake registers a temperature of 155°F.
6. Turn off the oven, leave the door shut, and let the cheesecake rest for 1 hour. Remove from the oven and the deep baking pan and let cool to room temperature. Once cool, refrigerate overnight. The next day, cut a slice and enjoy.

STEWED LIZARDFRUIT

I re-created this recipe by means of an old, five-part text that describes a feast given by Emperor Brazollus of the Reman Dynasty. The author, Arfons Jellicandante, was known for his expertise on Nibenese cuisine, but I rather think he was more interested in Brazollus's affairs. The text is sparse on culinary details, instead meandering between scandalous lists of the emperor's dalliances, countless jokes the emperor made at his brother-in-law's expense, and other irreverent witticisms. Between sordid details, I learned that the emperor was fond of Argonian cookery—this recipe in particular. I've adjusted it so the aftereffects are gone, but if you find your tongue going numb nonetheless, a quick spritz of rose water ought to recover you.

Level: ◁▮▮▭▷
Prep Time: 30 minutes
Cook Time: 10 minutes
Yield: 4 servings
Dietary Notes: Gluten-free, vegetarian
Cuisine: Argonian

LEMON WHIPPED CREAM

½ cup heavy cream

1 tablespoon powdered sugar

1 tablespoon lemon zest

2 teaspoons lemon juice

STEWED PLUMS

⅓ cup pomegranate juice

2 tablespoons water

½ cup granulated sugar

2 tablespoons light brown sugar

Pinch kosher salt

1 cinnamon stick

3 cardamom pods, crushed

8 plums, quartered and pits discarded

To make the lemon whipped cream:

1. In a bowl of a stand mixer, combine the heavy cream, powdered sugar, lemon zest, and lemon juice. Whip on high speed until it reaches stiff peaks. Cover the frosting bowl with plastic wrap and place in the refrigerator.

To make the stewed plums:

1. In a medium saucepan, combine the pomegranate juice, water, granulated sugar, brown sugar, salt, cinnamon, and cardamom pods. Bring to a boil, then reduce the heat to medium-low. Add the plums and simmer for 10 minutes or until the plums have softened.
2. Transfer to a bowl and top with lemon whipped cream to serve.

BEVERAGES

BEVERAGES

D rink is inlaid in the roots of Tamriel's history. With a little bit of digging, you'll find that many of those fateful events—events that turned our lands down one path rather than another—often occurred under the influence of wine, mead, or something else strong. From stories of the gods sipping ambrosia to Jarl Balgruuf drunkenly attempting to fight the dragon skeleton in his keep, drink makes people take extreme action. To think of how many wars began or ended because someone had too many pints of ale!

As I've mentioned, I wasn't terribly comfortable with alcohol in my youth. When I was a young Orc, I snuck a sip of some muddy drink my father had with his dinner. It was god-awful—I spat it out immediately, gagging and choking to the laughs of the miners. That same disgusting drink made the rest of our clan grow wild and raucous, all the things that a shy black sheep like me had a hard time with. It's no wonder I didn't have a great view of alcohol until I started traveling.

Even then, though, I didn't drink very much. Occasionally, yes, I'd share a drink with a fellow traveler just to ease the awkwardness, and I began to experiment a bit with drinks of very different flavors. I was pleased to discover that not all of it was as terrible as my father's ale. After meeting Arinmir, I was further encouraged to explore my own taste buds.

"It's a science, Urzhag," Arinmir wrote to me once. "Really, it's alchemy. It takes skill and rehearsal to find the perfect chemistry of flavors, but once you unlock it . . . well. You know the feeling of creating the perfect dish. Mixology is much the same. You ought to have some talent with it, at least. And if you won't make drinks for others, make a drink for yourself every now and then."

That last line was really what spurred me on. I had cooked for years at this point, and I knew what tended to work for different types of people all over the continent. But my own? I'd never made a dish solely to satisfy my own tastes. Yes, I knew the feeling of mastering a dish, but the focus was always outward—seeing other people enjoy my food made me happy. But perhaps I needed to approach mixology differently; perhaps I needed to start with myself.

For the rest of my journey, I made sure to try to find something I liked, drink-wise, at every stop. Not all the drinks were alcoholic! I was introduced to some lovely

coffees and teas which had me enamored. But though I found some pleasure in fruit-based liqueur and some fascination in more niche drinks, by the time I had finished my recipe collection, I still hadn't managed to find an alcoholic beverage that spoke to me.

Maybe drinks weren't really for me, then, and that was fine! I was ready to make my final few stops, drink or no, before meeting up with Balagog in Dawnstar. The first place I revisited was Solitude, where I'd begun my training in earnest. I had sent word to both Tsaltima and Arinmir and found them both waiting for me at the Winking Skeever. It was wonderful to come back to the place I had begun and see my friends—we talked, ate, and laughed into the night. After midnight, Tsaltima pushed a glass at me: a drink called the Old Epiphany. I put the glass to my lips without much expectation.

I'd be surprised if a fruit had ever bypassed Mor Khazgur's gates, and yet somehow this drink felt like coming home. I'd finally found the drink that suited my tastes. It felt like the true finale of my journey, the reward for my long travels and study, the closure I was looking for. The best ending, with a new beginning somewhere on the horizon.

With Arinmir's mixology expertise, Tsaltima's sweet tooth, my years of training, and the bartender's weary assistance, we broke down how to make the drink. I don't remember much more of that night except a vague memory of warmth and a bubbling in my chest, be it from too much Old Epiphany or the fun I was having.

The next morning, I woke to a short farewell note from Tslatima and a hungover, bedridden Arinmir who shooed me from his room. As I walked downstairs, my eyes lingered on the bar. It felt like just yesterday when I had sat there speaking to an older, finely dressed Orc. I toasted wordlessly to Balagog, walked out the door, and headed home.

BLACKWOOD MINT CHAI

I traced this recipe's origins to Leyawiin in Nibenay, possibly all the way back in the Merethic Era! Throughout history, this chai has been considered a luxury, often associated with times of great Imperial strength. Some accounts claim its roots lie with the great hero Pelinal Whitestrake, who many associate with Leyawiin due to their symbol of the Ivory Horse. Whether that is true or not, the tea was last popular during the rule of Uriel Septim VII in the Third Era. A noble sipping this cold tea as they held court would have been a common sight! I'm not sure why people stopped drinking it— perhaps just fashions going in and out—but I'd love to see a resurgence.

Level:

Prep Time: 20 minutes
Cook Time: 10 minutes
Inactive Time: 12 hours
Yield: 5 servings
Dietary Notes: Gluten-free, vegan
Cuisine: Imperial

ACAI BERRY SYRUP

4 ounces raspberries

1 tablespoon acai powder

1 mint sprig

1 cup sugar

1 cup water

ICED MINT CHAI

5 cups water

4 bags assam black tea bags

1 cinnamon stick

3 green cardamom pods

1 star anise pod

3 cloves

To make the acai berry syrup:

1. In a medium saucepan, combine the raspberries, acai powder, mint, sugar, and water. Bring to a boil. Reduce the heat to low and let simmer for 10 minutes. Lightly mash the raspberries. Cover and remove from the heat. Let steep for 45 minutes. Strain in a mesh strainer into a large pitcher.

To make the iced mint chai:

1. In a large pot, heat 5 cups of water over medium-high heat and bring to a light boil. Add the tea, cinnamon stick, cardamom, star anise, and cloves. Turn off the heat and steep for 5 minutes. Remove the tea bags, cover, and steep the rest of the ingredients for another 25 minutes. Strain, transfer to the pitcher with the syrup, and stir together.

2. Allow the combination to cool completely, then store in the refrigerator overnight before serving.

Until next time my friend.

— Tsatvirna

CORRUPTING BLOODY MARA

I first saw, or rather smelled, this drink in northern Skyrim. I'd been invited to a feast by a friend of an acquaintance who I didn't know well, but the invitation seemed gracious enough. The manor was awfully cold, and the host was mysterious but welcoming. When this drink was presented, though, the stench was so palpable that no other soul but the host even attempted to try it all night. Many moons later, I stumbled upon this similar-sounding drink while reading . . . about vampires! I felt a chill down my spine and thanked Mara that I had left that party in one piece.

I wanted to include this drink to remember the events of that evening, but this recipe has been significantly altered for the enjoyment of those more fond of the sun.

Level: ◁▭▭▭▭▷
Prep Time: 20 minutes
Inactive Time: 5 days
Yield: enough syrup for 3 cocktails
Dietary Notes: Dairy-free, gluten-free
Cuisine: Vampire
Equipment: Cocktail shaker, smoke gun

◆

INFUSED VODKA

9 ounces vodka

2 rosemary sprigs

1 tablespoon pink peppercorns

1 teaspoon coriander seeds

½ teaspoon fennel seeds

BLOODY MARA

7 ounces tomato juice

3 ounces infused vodka

1 teaspoon horseradish

2 teaspoons lemon juice

½ teaspoon Worcestershire sauce

2 dashes Tabasco

½ teaspoon fish sauce

Applewood chips, for smoking

ASSEMBLY (PER COCKTAIL)

1 tablespoon kosher salt

1 tablespoon black ground pepper

3 olives

3 gherkins

1 lemon, cut into 4 wedges

1 slice of bacon, cooked

To make the infused vodka:

1. In a small airtight container, combine the vodka, rosemary, pink peppercorns, coriander seeds, and fennel seeds. Store in the refrigerator for at least 5 days. Strain into another airtight container. Store in the refrigerator until needed. The infused vodka can be stored for several days (up to 2 weeks).

To make the Bloody Mara:

1. On a small shallow plate, combine the salt and pepper. Prepare a large glass by rubbing the rim with lemon juice. Place the glass in the salt and pepper mixture and rub the rim until the mixture sticks.

Note: You can sprinkle the mixture on, but it can be slightly messier on your table.

2. In a cocktail shaker, combine the tomato juice, vodka, horseradish, lemon juice, Worcestershire sauce, Tabasco, and fish sauce.

3. Follow the instructions of your smoke gun (or similar device) to add the smoke with applewood to the cocktail shaker. Once filled, cover and shake slightly. Let sit for 1 minute. Uncover and add three ice cubes. Cover again and shake vigorously for 15 seconds. Strain into the prepared glass.

4. Prepare the olives and gherkins by piercing them with a skewer. Top with a lemon wedge. Fill each glass with ice and add a skewer. Fill with the Bloody Mara and place a slice of bacon in the glass.

M'AIQ TALE

When Tsaltima joined me, we would travel around to various bars trying to find an alcoholic drink that I liked. One night, she ordered me this cocktail: I was head over heels for its refreshing bite and clean aftertaste! Thrilled to have finally found my drink, I allowed the night to carry me away. After a few hours of slipping inhibitions and laughingly telling Tsaltima the story of how my sister had nearly beheaded me on my thirteenth birthday, my Khajiiti friend burst into a fit of laughter. "This one has been lying to you. That drink is softer than Khajiit's tail—there is no alcohol!" I later found and read of this recipe, named after a particularly peculiar Khajiit known as a notorious fibber.

Level:
Prep Time: 15 minutes
Yield: 1 serving
Dietary Notes: Gluten-free, vegan
Cuisine: Khajiit
Equipment: Cocktail shaker

1 mint sprig leaves, plus more for garnish

2 lime slices, plus more for garnish

3 cucumber slices, plus more for garnish

4 ice cubes

1 tablespoon simple syrup

Note: If you want the drink to be extra sweet, add more simple syrup to taste.

4 ounces prickly pear cactus water

2 ounces horned melon

4 ounces lime sparkling water

1. In a cocktail shaker, muddle the mint, lime, and cucumber. Add the ice, simple syrup, and cactus water. Cover the shaker and shake vigorously for 10 seconds.

2. Prepare a large glass with a few ice cubes and scoop out the pulp of the horned melon into it. Strain the contents of the cocktail shaker into the cup. Top with the lime sparkling water. Garnish with additional mint, cucumber, and lime slices.

MUD NECTAR

I didn't get to spend much time in Black Marsh. Most Imperial caravans avoided it, due to the ongoing rebellions. I was, however, able to visit Soulrest through a series of happy coincidences. On the docks of Leyawiin, I overheard a raspy voice, passionately arguing the merits of Mud Nectar.

"The name given to this drink by men and Mer is doing it a disservice! In Jel, we call it—"

Unfortunately, I'm not skilled enough to translate the Saxhleel language into written word; regardless, I approached the speaker, who introduced themselves as Tun-Ei. Tun-Ei captained a small vessel that had two purposes: fishing to trade in Cyrodiil and ferrying Argonians to Soulrest. Tun-Ei was glad for someone willing to give Mud Nectar a chance and was sympathetic to my desire to see Black Marsh. They offered me one round trip to Soulrest on the condition that I write about the merits of Mud Nectar in my book. To be honest, I would've written about this lovely drink with or without the favor from Tun-Ei: its pure flavor and slight tang speak for itself. There's no wonder that Saxhleel on their way to Soulrest sip this drink to cleanse their souls.

Level:

Prep Time: 15 minutes
Inactive Time: 24 hours
Cook Time: 15 minutes
Yield: Enough syrup for 4 cocktails
Dietary Notes: Dairy-free
Cuisine: Argonian
Equipment: Cocktail shaker

DASHI SYRUP

2-inch square kombu

½ cup water

2 tablespoons dried bonito flakes

½ cup sugar

½ teaspoon kosher salt

MUD NECTAR

2 to 3 tablespoons dashi syrup

Note: If you want a sweet drink, make sure to add that extra dashi syrup to the cocktail shaker.

3 ounces Japanese whiskey

3 ounces sake

1 ounce lime juice

1 ounce yuzu juice

1 lime slice

To make the dashi syrup:

1. In a medium pot, place the kombu, cover, and let rest overnight. The next day, place the pot, uncovered, over medium heat. Right before the water comes to a boil, remove and discard the kombu. Add the bonito flakes, sugar, and salt and simmer for 15 minutes.
2. Strain through a fine-mesh strainer into a small airtight container and discard the ingredients. Let cool to room temperature. Store in the refrigerator for at least 12 hours and up to 2 weeks.

To make the Mud Nectar:

1. In a cocktail shaker, add the ice, dashi syrup, whiskey, sake, lime juice, and yuzu juice. Cover the shaker and shake vigorously for 10 seconds.
2. Prepare a highball glass with a few ice cubes. Strain the contents of the cocktail shaker into the cup. Garnish with a lime slice.

OLD EPIPHANY

The evening that Tsaltima, Arinmir, and I spent in Solitude is one of my most cherished memories. We toasted to the cookbook's success and spoke about our future plans. Tsaltima said she was heading back to Port Hunding—something about tying up loose ends. Arinmir was setting out to explore Tamriel—he wouldn't say it directly, but I think I inspired him! I told them I was heading home. I was looking forward to seeing my family and cooking some food for my clan. That same night I tried this drink, an ancient Altmer concoction, for the first time. Drinking it now still brings the memories of that night to my mind, and I hope it always will!

Level:
Prep Time: 15 minutes
Inactive Time: 5 days
Yield: 4 to 6 servings
Dietary Notes: Gluten-free, vegan
Cuisine: Altmer

PEACH & ORANGE INFUSED VODKA

4 ounces vodka

1 peach, sliced

1 orange, sliced

OLD EPIPHANY

4 ounces peach-and-orange-
 infused vodka

8 ounces peach nectar

8 ounces orange juice

2 ounces lemon juice

6 ounces fresh raspberries

3 apricots, sliced

2 peaches, slice

1 orange, sliced

750-ml bottle Moscato

To make the peach & orange infused vodka:

1. In a small airtight container, combine the vodka, peach, and orange. Let sit in the fridge for 4 days.

To make the Old Epiphany:

1. In a pitcher, combine the infused vodka, peach nectar, orange juice, and lemon juice. Add the raspberries, apricots, peaches, and orange and gently mix together. Cover and place in the refrigerator to rest overnight.
2. When you are ready to serve, add the Moscato and gently mix.

ORZORGA'S RED FROTHGAR

Here is another specialty that Chef Orzorga served at her famed banquet! While passing through Wrothgar, I ran into a trio of siblings, all yelling at each other. It turns out they were on their way to a wedding, but one of them had forgotten to bring wrathberries and they couldn't properly stain their teeth red for maximum intimidation. I happened to have a few on me after mixing this drink. They were so grateful that they even said they'd wed their sister off to me if I ever visited Morkul. (Bronk, if you're reading this, I'd still love to visit, but I'm sure Glaoga can find a more robust husband than I!)

Level:

Prep Time: 30 minutes
Cook Time: 30 minutes
Inactive Time: 12 hours
Yield: 8 servings of comberry simple syrup
Dietary Notes: Dairy-free, gluten-free, vegetarian
Cuisine: Orsimer
Equipment: Cocktail shaker

COMBERRY SIMPLE SYRUP

¼ cup sugar

½ cup honey

½ cup water

2 ounces lingonberry

2 ounces red currants

2 lemon peels

RED FROTHGAR

1 ounce blackberries

½ rosemary sprig,
 plus 1 sprig for garnish

4 ice cubes

1 ounce Comberry Simple Syrup

2 ounces gin

½ ounces elderflower liqueur

5 ounces ginger beer

1 ounce tonic water

To make the comberry simple syrup:

1. In a medium saucepan, whisk together the sugar, honey, and water over medium-high heat. Once the sugar dissolves, add the lingonberry, currants, and lemon peels and bring to a simmer. Reduce the heat to medium-low and simmer for 25 minutes. Remove from the heat and let cool.
2. Strain into a small airtight container. Let cool to room temperature. Store in the refrigerator for at least 12 hours and up to 2 weeks.

To make the Red Frothgar:

1. In a cocktail shaker, muddle the blackberries and rosemary. Add ice, comberry simple syrup, gin, and elderflower liqueur. Cover the shaker and shake vigorously for 10 seconds.
2. Prepare a large glass with a few ice cubes. Strain the contents of the cocktail shaker into the cup. Top with the ginger beer and tonic water. Garnish with a rosemary sprig.

PSIJIC AMBROSIA

Ah, the coveted Psijic Ambrosia, as old as the Psijic Order itself! Only a talented and persevering mixologist can make the true form of this drink, as Perfect Roe is almost impossible to find. It is rumored that even one sip of the ambrosia will grant you bursts of wisdom beyond your years—though I tend not to put too much stock in tales like that. Instead, I recommend this slightly more accessible version of the drink, which tastes just as delectable without a lick of magic.

Level: ◁▭▭▭▭▭▷
Prep Time: 15 minutes
Cook Time: 20 minutes
Inactive Time: 2 hours
Yield: 4 servings
Dietary Notes: Dairy-free, gluten-free
Cuisine: Altmer
Equipment: Cocktail shaker, tea infuser

◆

GYOKURO TEA

4 cups water

1 lemongrass stalk

2-inch piece ginger

2 tablespoons sugar

2 tablespoons gyokuro green tea leaves

PER COCKTAIL

4 ice cubes

½ lime, juiced

¼ teaspoon fish sauce

½ cup brewed Gyokuro Tea

¼ cup Japanese whiskey

½ cup ginger beer

1 lime wedge

Note: The gyokuro green tea leaves can be substituted with genmaicha, but in a pinch, any green tea (aside from matcha) would work.

To make the Gyokuro Tea:

1. In a medium saucepan, combine the water, lemongrass, ginger, and sugar. Bring to a boil and then reduce to a simmer for 15 minutes. Remove from the heat and let cool until it reaches 135°F. Remove the lemongrass and ginger and place both in a pitcher.

2. Using a tea infuser, add the gyokuro tea leaves to the saucepan. Let it infuse for 90 seconds. Strain through a mesh strainer and pour into the pitcher. Let cool completely, about 1 hour. Place in the refrigerator and let cool for at least 1 hour.

To make the Psijic Ambrosia:

1. In a cocktail shaker, add the ice, lime juice, fish sauce, brewed tea, and whiskey. Shake for 10 seconds. Fill a glass halfway with ice. Pour the mixture from the shaker (do not include the ice). Add the ginger beer to the glass and stir lightly. Garnish with a lime wedge.

TELVANNI TEA

House Telvanni, one of Morrowind's Great Houses, are still known today as magnificent wizard-lords, though the Fourth Era has not been kind to them: The House has been ravaged by the Argonian Invasion and the eruption of the Red Mountain. From what I've read, though, their capital of Sadrith Mora was once a bio-magical marvel, with enormous mushrooms that were grown, cultivated, and shaped into dwellings! I would've loved to experience the House at their height, but I'll make do with sipping this tea, imagining myself on a mushroom balcony overlooking Zafirbel Bay.

Level:

Prep Time: 2 minutes

Inactive Time: 5 minutes

Yield: 2 cups

Dietary Notes: Vegetarian

Cuisine: Dunmer

2 blue lotus flowers

1 tablespoon dried lemongrass

1 tablespoon Earl Grey tea

½ tablespoon acai powder

2 orange peels

2 tablespoons honey

2 cups hot water (200°F)

1. In a small teapot, place the lotus flowers, lemongrass, Earl Grey tea, acai powder, orange peels, and honey. Add the hot water and steep for 5 minutes. Strain through a fine-mesh strainer and serve.

Note: You can do a second steep with this mixture if you are looking for more tea. Just make sure to add another portion of honey to the teapot.

YOU-KNOW-WHAT WHISKEY

The Bosmer are particularly fond of this drink. While traveling through Greenshade, I was hosted by numerous families, many of whom had their very own fascinating distilleries. When I finally made it to Woodhearth, I felt a bit of a whiskey connoisseur—but how wrong I was. I tried to impress a Bosmeri innkeeper in the city but was quickly out of my depth as they started pouring me glass after glass! I can only remember not wanting to seem rude and waking up with a terrible headache the following afternoon.

Level: ◁▭▭▭▭▭▷
Prep Time: 20 minutes
Inactive Time: 24 hours
Yield: 4 servings of bourbon
Dietary Notes: Dairy-free, gluten-free
Cuisine: Bosmer
Equipment: Coffee filter

BACON-INFUSED BOURBON

1 ounce bacon fat

8 ounces bourbon

YOU-KNOW-WHAT WHISKEY

½ ounces maple syrup

2 dashes orange bitters

2 ounces bacon-infused bourbon

3 large ice cubes

1 orange peel

1 piece bacon, cooked

To make the bacon-infused bourbon:

1. In a small plastic airtight container, combine the bacon fat and bourbon. Cover and shake vigorously. Place in the freezer and let rest for at least 1 day (up to 4 days).
2. The next day, strain the mixture through a coffee filter. Place the bourbon in a new small airtight container. The bourbon can be stored in the refrigerator for up to 2 weeks.

To make the You-Know-What Whiskey:

1. In a mixing glass, stir the maple syrup and bitters together. Add the bourbon and two ice cubes. Mix together until chilled.
2. Prepare a rocks glass with one ice cube, orange peel, and bacon. Strain the bourbon mixture into the glass.

HIGH ROCK ROSE AND RYE

My prickly friend Arinmir wrote to me about this High Rock staple from his research sabbatical in Daggerfall. From what I could piece together, he spent most of that time sampling different refreshments and bemoaning how unappreciated he was at the College: "My valuable contributions continue to be ignored, and thus, I find my comforts not in quills, scrolls, and tomes, but in the aroma of a rose, mint, and ginger concoction. You know, Urzhag, I've always felt some kinship with the Breton—always considered 'second-best' sorcerers behind the Altmer greats! Were they to be given a fair chance, who knows what I—I mean, they—could do?"

Though Arinmir can be a touch dramatic, he's not wrong about this refreshing beverage.

Level:
Prep Time: 15 minutes
Cook Time: 30 minutes
Inactive Time: 24 hours
Yield: Enough syrup for 5 cocktails
Dietary Notes: Vegan
Cuisine: Breton
Equipment: Cocktail shaker

ROSE AND GINSENG SYRUP

½ cup sugar

½ cup water

2 tablespoons dried rosebuds

2 fresh ginseng roots

HIGH ROCK ROSE AND RYE

1 mint sprig

3 ice cubes

1 tablespoon rose and ginseng syrup

2 ounces rye whiskey

½ ounces lemon juice

4 ounces ginger beer

1 dash bitters

To make the rose and ginseng syrup:

1. In a small saucepan, whisk together the sugar and water and place over medium-high heat. Once the sugar dissolves, add the rosebuds and ginseng roots and bring to a simmer. Reduce the heat to medium-low and simmer for 25 minutes. Remove from the heat and let cool.
2. Strain into a small airtight container. Let cool to room temperature. Store in the refrigerator for at least 12 hours and up to 2 weeks.

To make the High Rock Rose and Rye:

1. In a cocktail shaker, muddle the mint. Add the ice, rose and ginseng syrup, rye whiskey, and lemon juice. Cover the shaker and shake vigorously for 10 seconds.
2. Add the ginger beer and bitters. Strain through a fine-mesh strainer into a glass.

TANETH COFFEE

I sipped this aromatic pick-me-up on the mainland of Hammerfell, but the coffee carries with it the vestiges of an island myth of the Second Era. The barista was a young Redguard whose family is still in Stros M'Kai. She told me what she could remember her mother telling her of the story: something to do with pirates, a prince, and a possessed sword—she couldn't remember much. But she did remember these words, as they're repeated by the youth of the island: "They will hear of this in the rest of Hammerfell" and "Then let's make sure it's loud."

Level:
Prep Time: 10 minutes
Yield: 1 cup
Dietary Notes: Dairy-free, vegetarian
Cuisine: Redguard
Equipment: French press

24 grams (¼ cup) ground coffee

Note: Any kind of coffee should work, but a lighter roast will have more spice and floral notes, whereas a darker roast will hold more of the roasted coffee flavor.

¼ teaspoon ground cinnamon

¼ teaspoon grated nutmeg

½ teaspoon ground cardamom

Pinch kosher salt

Pinch ground black pepper

450 grams (2 cups) water (212°F)

2 tablespoons honey

1. In a small bowl, combine the ground coffee, cinnamon, nutmeg, cardamom, salt, and pepper. Pour the mixture into a French press.
2. Pour the water just off boiling into the French press, lightly stir, and let sit for 4 minutes.
3. Add the honey to a mug. Plunge the French press, pour the prepared coffee in the mug, and stir until combined.

WITCHMOTHER'S PARTY PUNCH

I spent some weeks in Hearthfire and Frostfall working my way through the swamps of Glenumbra and finally arrived in Camlorn for the Witches Festival. The people of Camlorn were welcoming, and I delighted in getting to share their poetic joy for life. Most evenings, we sat around a campfire drinking this wonderful punch from a cauldron. One particularly grizzled old woman told me the story of the drink's creation: long ago, a powerful conjurer that many called the Witchmother would appear on the thirteenth of Frost Fall and call others to gather ingredients to make her brew. If the brew was made, the Witchmother would give a curse that turned all who drank the brew into terrifying but powerful beasts. If the brew was not made, the Witchmother would return to her ancient coven in the forests to the south and drink the Witchmother's Party Punch until the following year, when she had a chance to rise again . . .

Level: ▭▭▭▭
Prep Time: 15 minutes
Inactive Time: 8 hours
Yield: 6 to 8 servings
Dietary Notes: Vegan
Cuisine: Witch

2 plums, sliced

2 Bosc pears, sliced

1 nectarine, sliced

1 lemon, sliced

1 cup rye whiskey

½ cup Luxardo maraschino liqueur

1½ to 3 cups pomegranate juice

3 to 5 cups ginger beer

1. In a pitcher, combine the plums, pears, nectarine, lemon, rye whiskey, maraschino liqueur, and pomegranate juice. Let the punch sit in the refrigerator overnight.
2. Right before serving, add the ginger beer.

Note: To make the party punch a bit less potent, add more ginger beer and pomegranate juice.

AFTERWORD

And now it's finished. This collection of recipes, this historical record, this scrapbook of my dearest memories. My journey and my heart, sturdily bound between two hard covers and released into the wild. Served to the world on a platter. Thank you, again, for staying with me through these pages—and if it's all the same, please stick with me for just one or two more.

In the days of my tutelage, I often presented finished dishes to Balagog with a mix of pride and trepidation. He always began his judgment in the same way: first with a hearty sniff, then three slow bites, chewing carefully, considering the flavors and the texture. If I'd gotten it right, he'd chuckle in his throaty tenor and, without fail, give this curious compliment: "This is high-quality kindling."

I never really understood what that meant, until now.

In my quest to write this book, I accomplished more than I could have ever dreamed at the start. I learned how to set myself up for success. I discovered the difference between expensive tools and true skill—not that you can't have both. I stopped using history as an escape and began to explore it as a foundation for culture and courage. I grew communities around my cooking! I had wild, death-defying adventures and made friends I will keep for life. I gained the priceless ability to prioritize myself when I need to—a skill that I hope to continue honing. I fanned the flames of my own inspiration. I returned home and shared a drink with my father.

It was sweet, and not just because of the nectar in the Epiphany. No one will ever accuse Chief Larak of being sentimental, but I could tell he was proud of me.

"You're made of impressive metal, Urzhag," he said to me. "What's your plan now? Might be time for you to return to Mor Khazgur for good."

I'd been thinking about this already, oddly enough. What could possibly follow the adventure of a lifetime? "The End" had barely begun to sink in. I'd modeled my path after my mentor's—but that path was at its end.

I brought the first, nearly complete copy of this book to Balagog's memorial. I wanted to burn it with the pyre and pass it to him in the afterlife. Leading up to the moment, I imagined placing my heavy stack of papers on the pyre—presenting it to him, as I used to do with all those dishes at the Winking Skeever so many years ago. I imagined a feeling of . . . release. I thought it'd mean letting go. But when I stood next to the pyre, feeling the heat on my skin, I had a sharp and sudden recollection of Balagog chuckling.

"This is high-quality kindling."

So that's what he'd meant! It slid into place as easily as melted butter and moon sugar. I may have finished my work—mastered the recipes, completed the book— but my journey wasn't over. My flame would only grow, stoked by the work I'd done, the passion I'd fueled. I watched the pages of my heart burn into smoke, drifting up into the night sky, and I knew that I would never let go. I didn't want to.

So when my father suggested settling down, I knew my answer.

To his credit, he didn't try to stop me. I think he could see that I'd finally found myself—and it'd be a shame if I didn't then get to spend some time with the person I'd found. Besides, I had done much and traveled far, but had I done everything I'd wanted to? I've still not seen much of Black Marsh—I'm sure there are still many wondrous fungi to be tasted among its trees. I've heard of an ancient temple called Y'ffelon, but never managed to track its location down. I promised Hasah and Irrielle I'd visit Turnpoint in autumn; their daughter has started to take her first steps! Tsaltima has been itching to do a desert-sampling tour along the coast of Elsweyr. And for all Arinmir's complaints, there is still so much knowledge to be gained from the College of Sapiarchs.

All of this and more to say: What follows the adventure of a lifetime? What's next, after the end? First, probably, a rest—and then, another beginning. Perhaps I'll write another volume—or perhaps the next adventure will be for just me and those closest to me.

Either way, it will be high-quality kindling.

ABOUT THE AUTHORS

VICTORIA ROSENTHAL launched her blog, Pixelated Provisions, in 2012 to combine her lifelong passions for video games and food by recreating consumables found in many of her favorite games. When she isn't experimenting in the kitchen and dreaming up new recipes, she spends time with her husband and corgi hiking, playing video games, and enjoying the latest new restaurants. Victoria is also the author of *Fallout: The Vault Dweller's Official Cookbook*; *Destiny: The Official Cookbook*; *Magic: The Gathering: The Official Cookbook: Cuisines of the Multiverse*; and *The Ultimate FINAL FANTASY XIV Cookbook*. Feel free to say hello on social media at PixelatedVicka.

ERIN KWONG is a writer and narrative designer of video games, board games, and everything in between. She is a lifelong fan of playable stories, and enjoys subjecting her loved ones to playing with her. In her spare time, she directs the local ballet company in her hometown of Rockville, Maryland.

DIFFICULTY INDEX

APPRENTICE

ADEPT

EXPERT

GOURMET

DIETARY CONSIDERATIONS

V = Vegetarian **V+** = Vegan **GF** = Gluten-free **DF** = Dairy-free

BREAKFAST

Arenthia's Empty Tankard Frittata		GF	DF
Bubble and Squeak		GF	
Fungus Omelet	V		DF
Kwama Hash	V		
Old Aldmeri Orphan Gruel	V+		DF
Pear Sweetcakes	V		
Solitude Full Breakfast			
Toad Muffin			
Orzorga's Tripe Trifle Pocket			
Rajhin's Sugar Claws	V		

APPETIZERS

Alik'r Beets with Goat Cheese	V		
Falinesti Forbidden Fruit	V	GF	
Gold Coast Mudcrab Fries			
Kollopi			
Caramelized Goat Nibbles		GF	DF
Troll Fat Jerky			DF
Elsweyr Corn Fritters	V		
Singing Tuber Salad	V		
The Hound and Rat			

BREAD

Combwort Flatbread	V+	
Minstrel Banana Bread	V	
Savory Thorn Cornbread		
Solitude Bread	V	DF
Vvardenfell Ash Yam Loaf	V	
Candied Nectar Bread	V+	

SOUPS AND STEWS

Argonian Pumpkin Stew		GF	DF
Artaeum Takeaway Broth		GF	DF
Cloudy Dregs Inn Bouillabaisse			DF
Elsweyr Hearty Noodles			DF
Hunt-Wife's Beef Radish Stew			DF
Lava Foot Soup and Saltrice		GF	DF
Mutton Stew		GF	DF
Pack Leader's Bone Broth		GF	DF
Shornhelm Oxtail Soup			DF
Solitude Salmon-Millet Soup		GF	
West Weald Corn Chowder	V		

ENTRÉES

Artaeum Pickled Fish Bowl			DF
Orcish Bratwurst on Bun			DF
Peacock Confit		GF	DF
Roast Branzino		GF	DF
Garlic and Pepper Venison Steak			DF
Pheasant Roast			DF
Port Hunding Cheese Fries			
Senchal Curry Fish and Rice			DF
Stonetooth Bash Chicken		GF	DF
Apple Mashed Potatoes	V		
Ashlander Ochre Mash	V		
Bravil's Best Beet Risotto	V	GF	
Gilane Garlicky Greens	V+	GF	
Hearthfire Harvest Pilaf		GF	DF

DESSERTS

Fargrave Sweetrolls	V	
Colovian War Torte	V	
Sanguine "Shaven Fruit"	V	
Banana Surprise	V	
Jubilee Cake	V	
Marshmerrow Cookies	V	
Pumpkin Cheesecake	V	
Stewed Lizardfruit	V	GF

BEVERAGES

Blackwood Mint Chai	V+	GF	
Corrupting Bloody Mara		GF	DF
M'aiq Tale	V+	GF	
Mud Nectar			DF
Old Epiphany	V+	GF	
Orzorga's Red Frothgar	V	GF	DF
Psijic Ambrosia		GF	DF
Telvanni Tea	V		
You-Know-What Whiskey		GF	DF
High Rock Rose and Rye	V+		
Taneth Coffee	V		DF
Witchmother's Party Punch	V+		

MEASUREMENT CONVERSION CHARTS

VOLUMES

US	METRIC
⅕ teaspoon	1 ml
1 teaspoon	5 ml
1 tablespoon	15 ml
1 fluid ounce	30 ml
⅕ cup	50 ml
¼ cup	60 ml
⅓ cup	80 ml
3.4 fluid ounces	100 ml
½ cup	120 ml
⅔ cup	160 ml
¾ cup	180 ml
1 cup	240 ml
1 pint (2 cups)	480 ml
1 quart (4 cups)	.95 liter

TEMPERATURES

FAHRENHEIT	CELSIUS
200°	93.3°
212°	100°
250°	120°
275°	135°
300°	150°
325°	165°
350°	177°
400°	205°
425°	220°
450°	233°
475°	245°
500°	260°

WEIGHT

US	METRIC
½ ounce	14 grams
1 ounce	28 grams
¼ pound	113 grams
⅓ pound	151 grams
½ pound	227 grams
1 pound	454 grams

INSIGHT
EDITIONS

PO Box 3088
San Rafael, CA 94912
www.insighteditions.com
⬛ Find us on Facebook: www.facebook.com/InsightEditions
⬛ Follow us on Instagram: @insighteditions
©/™ 2024 ZeniMax

Published by Insight Editions, San Rafael, California, in 2024.

ISBN: 979-8-88663-424-2
Publisher: Raoul Goff
VP, Co-Publisher: Vanessa Lopez
VP, Creative: Chrissy Kwasnik
VP, Manufacturing: Alix Nicholaeff
VP, Group Managing Editor: Vicki Jaeger
Publishing Director: Mike Degler
Art Director and Designer: Catherine San Juan
Editor: Sadie Lowry
Editorial Assistants: Alex Figueiredo and Jeff Chiarelli
Managing Editor: Maria Spano
Senior Production Editor: Nora Milman
Production Manager: Deena Hashem
Senior Production Manager, Subsidiary Rights: Lina s Palma-Temena

Text by Victoria Rosenthal and Erin Kwong
Photography by Victoria Rosenthal
Illustrations by Erika Hollice

Insight Editions, in association with Roots of Peace, will plant two trees for each tree used in the manufacturing of this book. Roots of Peace is an internationally renowned humanitarian organization dedicated to eradicating land mines worldwide and converting war-torn lands into productive farms.

Manufactured in China by Insight Editions

10 9 8 7 6 5 4 3 2 1

The Empire of Tamriel